ATGET

JOHN SZARKOWSKI

❧

ATGET

❧

The Museum of Modern Art

This reprint is made possible by the John Szarkowski Publications Fund.

Produced by the Department of Publications
The Museum of Modern Art, New York

Edited by Harriet Schoenholz Bee
Designed by Gina Rossi
Production by Christopher Zichello, Matthew Pimm
2012 reprint tritone separations by Thomas Palmer
Typeset in Adobe Garamond
Printed on 150gsm Mori Silk
by Asia One Printing Limited, Hong Kong

Library of Congress Catalogue Card Number 00-102226
ISBN 978-0-87070-094-1

Published by The Museum of Modern Art
11 West 53 Street, New York, New York 10019-5497. www.moma.org

Distributed in the United States and Canada by ARTBOOK | D.A.P.,
155 Sixth Avenue, 2nd floor, New York, NY 10013. www.artbook.com

Distributed outside the United States and Canada by Thames & Hudson Ltd,
181A High Holborn, London WC1V 7QX. www.thamesandhudson.com

Cover: Eugène Atget. *Versailles, parc.* (1901)

Printed in Hong Kong

CONTENTS

ACKNOWLEDGMENTS

I am in debt to all those who have written about Eugène Atget—even those who have written in French, whom I have understood very imperfectly, or in German, whom I have understood not at all, except through the courtesy of an intermediary. Even in these cases, I am the beneficiary of at least part of their thought, as it has been recast in the thought of others. Ultimately, the thoughts that we hold with reasonable confidence are doubtless the constructions of a community.

Nevertheless, I am especially indebted to the writings of Ferdinand Reyher, John Fraser, and my friend and colleague Maria Morris Hambourg, who seem to have written about Atget with special sensitivity and precision.

I am also grateful for what I have learned about Atget from looking at the work of photographers who learned so much from him, especially (of course) Walker Evans and Lee Friedlander.

Like everyone else who is interested in the problem of printing photographs in ink, I am grateful to Richard Benson, who has made better books possible. It was Benson who, years ago, helped the Museum solve the very complex problem of reproducing Atget's prints, and his advice on this volume has been of invaluable assistance to Christopher Zichello, the production manager for this book, and to me. My thanks go to Chris and to Marc Sapir for their meticulous attention to all the details of production and to Gina Rossi for her sensitive design for this volume.

The three successive Atget curators at The Museum of Modern Art—Yolanda Terbell, Barbara Michaels, and Maria Hambourg—established between 1968 and 1985 a structured body of objective knowledge based on the primary evidence of the work itself. The indispensable work of Terbell and Michaels was completed and resolved in the synthesis of Hambourg, whose solution to the problem of dating Atget's work provided the framework on which all subsequent analysis would depend. As I have said elsewhere, her work constitutes the most important achievement in Atget scholarship.

The fruits of that work might still be the privileged resource of a few scholars if it had not been for the support of the four-volume *The Work of Atget* (1981–85) by Springs Industries, with its enthusiastic chairmen Peter G. Scotese and (later) Walter Elisha. In many ways, the current book is a child of the earlier volumes.

The staff of the Museum's Department of Photography has been unfailingly gracious and helpful, and I must especially thank Sarah Hermanson for her imaginative assistance with a variety of research problems. My deepest gratitude must go to Peter Galassi, Chief Curator in the department, for his encouragement and incisive criticism.

I owe a debt of gratitude as well to the Museum's publisher Michael Maegraith, whose understanding and imaginative support made this endeavor possible, and to Nicholas Callaway and his staff for their enthusiastic and enlightened collaboration on the project.

Finally, I would like to thank my editor Harriet Schoenholz Bee, who has—once again—succeeded in improving my prose without damaging our friendship.

John Szarkowski

❧

ATGET

❧

INTRODUCTION

About Eugène Atget, the man, we have only a handful of semireliable facts, and they are mostly opaque or ambiguous. Scholars have pummeled and shaken them without mercy, but for the most part they have stood mute. About Atget as a photographer we know much more, since we know his work, and a good deal about the photographic history of which he was a part. He became a photographer in the late eighteen eighties, at a time when two changes in photography's standard technical vocabulary were very new. These changes were revolutionary in their effects, not only on photography's means, but on its ends. The first of them was the invention of sensitive plates that could be bought in stores, and it revised photography almost overnight. The other was the invention of the halftone engraving, which permitted photographs to be printed in ink, along with text, at a very small fraction of the cost of the traditional chemical photograph. This second change did not seem terribly important at first, and did not reveal its full revolutionary significance until the early twentieth century.

Neither change is conceivable except in an industrial economy, in which money will (perhaps) follow a good (or potentially profitable) idea. (The same thing can be said of oil colors in tubes, and of inexpensive books, and of ready-made clothes.)

Berenice Abbott. *Eugène Atget.* 1927

Thus this new era in the history of photography marks a deep disjuncture with the medium's earlier nature. The invention of photography was a slightly tardy achievement of eighteenth-century thought: the scientists and artists who invented it were interested (one might say) in the problem of how chemistry might marry the geometry of optics and the energy of light. Once that abstract problem was solved, photography was quickly snatched from the hands of the philosophers, and delivered into the hands of the entrepreneurs. Nevertheless, the resulting commerce was for half a century practiced largely on cottage-industry principles: photographers did not grind their own lenses, but they did sensitize their own plates and their own printing paper, according to their own recipes. They were perhaps the last wizards of the old dispensation.

Atget, who (it is thought) began photography in his thirties, and his slightly younger contemporary Alfred Stieglitz, came to the medium just after it had thrown off its old-fashioned ways. (Stieglitz complained bitterly, and almost continually, about the inadequacy of the proprietary materials that he bought in shops, but it seems not to have occurred to him that he might have made his own, as photographers had routinely done when he was in high school.) Plates made in factories, and then film, had made photography easy. Wizardry was irrelevant; anyone, even a child, could do photography.

The new materials not only made it easy to make a photograph; they made it easy to make many photographs quickly. The historian Joel Snyder estimates that Timothy O'Sullivan, working in the American West during the wet-plate era, might have worked a maximum of three locations on a good day, and exposed perhaps eight or ten plates. If he moved his camera and tripod farther (as a guess) than he could throw a baseball, he would also move his entire outfit: dark tent, chemicals, water, and miscellaneous paraphernalia; before making an exposure he needed to coat his plain glass plate with a collodion emulsion, sensitize the emulsion with a solution of silver salts, expose his plate in the waiting camera, and return it to the dark tent for development before its emulsion had begun to dry. Such a method encouraged a judicious consideration of the chances of success. The wet-plate photographer was unlikely to expose half a dozen plates in the hope of getting a good one.

After the invention of the dry plate the photographer left his laboratory at home, and until the invention of the automobile he could shoot in a day more plates than he could carry. After the automobile there was no limit.

Photography had been from its beginnings quite permissive about what subjects were worth recording. Even with the daguerreotype, it seems that every man above the rank of day laborer, as well as many day laborers, and millions of women, were first given a visual record of their existence. But with the dry plate the bar was dropped virtually to the ground. Now almost everything was photographed: not only masterpieces, but every old painting, every ancient pot, every banquet,

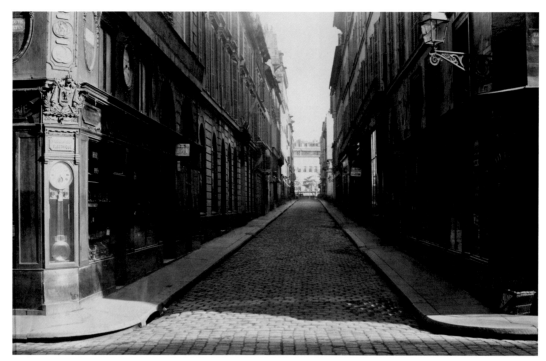

Charles Marville. *Rue de Choiseul, Paris.* (c. 1865)

every school class, almost every picnic. Which of us grew up in a building that was never photographed? In the wet-plate days Atget's great predecessor Charles Marville photographed the streets of Old Paris, street by street. In those old streets that still existed a generation later, Atget repeated the work building by building, sometimes door by door, sometimes door knocker by door knocker. He reworked the ore with a finer screen, and sifted out a different precious metal.

The second radical change that revised photography in Atget's time was the rise of photomechanical reproduction, which allowed photographs to be printed in ink on ordinary paper, along with text, on a single pass through the printing press. This was, or seemed to promise, an answer to the two complaints that had dogged photography during its first half-century: that it was too expensive, and too impermanent. Both complaints were at least half true. Photographs could not be produced in substantial editions nearly as cheaply as lithographs or engravings of the same size, and the harder photographers tried to meet the price of traditional prints the more likely they were to cheat a little on the long, laborious treatments that might exorcise from their prints the chemical devils that would make them fade or yellow.

The halftone plate (which produced the illusion of continuous tone by juxtaposing smaller and larger dots of ink on a regular grid) solved both of these problems. Five hundred copies might cost only twice as much as one, and the ink—mostly carbon—was more permanent than the paper it was printed on. It is true that, in the beginning, the halftone print was a surly blot of ink that resembled

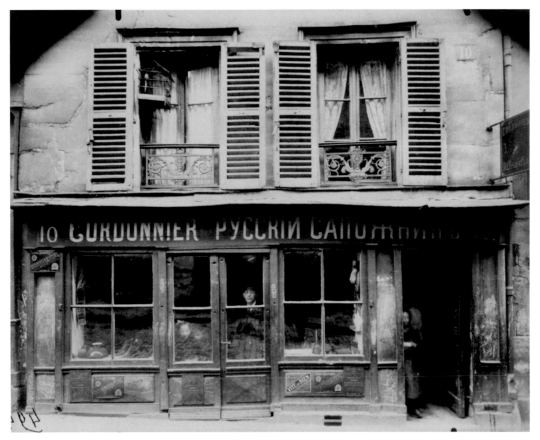

Eugène Atget. *Vieille boutique, rue des Lyonnais, 10.* (1914)

only marginally the beloved chemical photograph, which was as smooth in tone as the inside of an oyster shell, and which allowed us, it seemed, to count the hairs on a beloved head. But that would be corrected, almost completely, in time.

❧

On reflection—and surprisingly—it would seem that these two great technological changes worked at cross purposes to each other. The dry plate (and the long line of incremental advances that have grown naturally from it, even including the disposable camera) has made it increasingly easier to make an ever larger number of photographs, whereas the halftone plate determined that a smaller and smaller portion of this flood of pictures would ever reach the public—although the few that did would be seen by very large numbers.

The effects of the new circumstances seem predictable in retrospect, although they were surely not at the time. Five hundred prints of a photograph in ink might not cost much more than one, but the first one was very expensive, and a photograph of potential interest only to ten, or one hundred, buyers was unlikely to be elected for reproduction by the new method. And it was no longer the photographer who decided which pictures might interest a broad audience, but the

publisher. The publisher paid the printer. Thus most professional photographers, who under the old system had themselves been small publishers, became occasional contributors to a complex publishing network.

The exceptions were portrait photographers, and specialists such as Atget, whose work was made to satisfy a very small clientele. The advantage of this circumstance was that the photographer need not concern himself with popular taste; the disadvantage was that he did have to concern himself with narrow, esoteric taste. Neither condition of servitude is one that a photographer would be likely to choose in an ideal world, but the historic fact is that the lot of the professional photographer has seldom been a happy one.

To summarize the broad cultural effects of the two radical technical innovations that we are considering, we might say that they created an enormous increase in the number of photographs made and a comparable decrease in the percentage of those photographs that served a commercial function. This is to say that by the twentieth century photography had suddenly become a primarily amateur enterprise. And it has remained so, in the sense that its equipment and materials industry, its periodicals, and the organizations that serve its special interests are fundamentally focused on the nonprofessional market.

The new amateur photography of the turn of the century was clearly art of a sort, at least in the limited sense that it served no other obvious function. Commercial photography, which did serve other functions, came to be seen as the opposite of art photography, and art photography came to be defined primarily in terms of the photographer's motives, rather than the vitality of the work. In these terms Atget was simply not part of the world of art photography. If a photographer from that world should have happened upon a score of Atget's prints, they would probably have elicited no response. He was playing an unrelated game.

The idea of divorcing photography's purist and mundane ambitions was doomed to fail, to the detriment of photographers on both sides of the divide, but surely the purists lost the most, for they sacrificed vitality, while the working photographers sacrificed only elegance of finish. If confronted with the burning building test, which of us would not rescue the work of Lewis Hine, with all its blemishes, before that of his neighbor and contemporary Clarence White, with all its perfection?

But even if all of this is true, it is perhaps not quite the point that should be made. For what excites us in Atget is not that he avoids inanity, but that he shows us an unfamiliar world, full of rhythms and consonances that we had not heard before, and of allusions to experience that we had wholly forgotten, or that we had perhaps never known.

To start again, one might say that most photographers of Atget's time believed, or felt, that the subject was a given, that its objective, public nature was clear and obvious. Most working photographers felt that it was their job to describe this objective thing as clearly and as precisely as possible. Most art photographers felt

that it was their role to manipulate or inflect that objective reality by submitting it to the force of artistic principal and artistic sensibility. With Atget we feel no application of artistic principle or sensibility, only the attempt to describe clearly and precisely what is in front of the camera, but what is out there now seems not secure and objective but contingent, provisional, relative, capable of continual speciation. Even in his most fully resolved pictures, the formal perfection describes an experience as ephemeral as the moment of stillness at the apogee of a dancer's leap.

It was Atget's recognition of the endless plasticity of the world that enabled him to return over and over to the same motifs, knowing that they would always be new. He did not need to concern himself with revising the world by the strength of his imagination, if he could remain alert to the world's own constant revision of its self.

<p align="center">❧</p>

Photography is now more than a century and a half old, and on most days its tradition still seems woven of ignorance and incoherence. Its most revered practitioners, even in the twentieth century, seem to have appeared spontaneously, as volunteers, from no known seed, and to have produced their work merely out of talent, intelligence, and will. But this is surely an illusion. Photographers are marked as deeply as painters or poets by work that startles them to high attention, even if that work comes to them without a name or a formal introduction.

Atget's greatest student—and the photographer who came closest to becoming his artistic successor—was surely Walker Evans. It seems now that Evans worked his way through Atget's whole iconographical catalogue, save only the parks. Evans did the bedrooms and kitchens, the boutiques, the signs, the wheeled vehicles, the street trades, and the ruins of high ambition. He did not have Versailles, of course, only ruined ante-bellum plantations, failed banks in the classical idiom, and fragments of stamped-tin ornament. To rework Atget in America required that Evans recognize that he was dealing with a different order of tradition and quality, and this recognition inevitably inflected his work with irony—a condition that seems foreign to Atget's view of the world.

But it was in fact decades before it was noticed that Evans had reworked Atget's catalogue of potential subject matter. Perhaps the relative simplicity and transparency of photographic craft helps disguise the process by which photographers learn from their predecessors. Young poets and painters may work their way toward meaning through the code of craft, learning first to match, approximately, the sounds and rhythms, or the layering of colors, and in this way approach the issue of content. Whereas it may be that young photographers, if sufficiently bold and alert, can go straight to meaning.

Some support for this speculation might be deduced from the negative examples of those masters whose styles have been, one might say, overly seductive, and

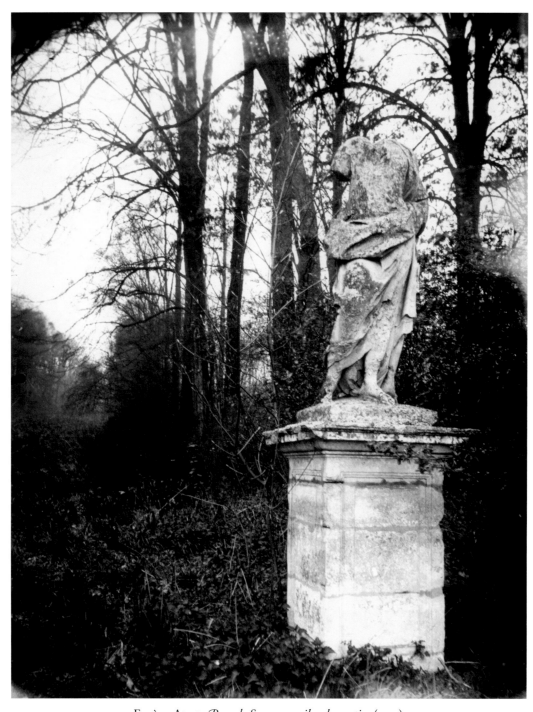

Eugène Atget. *Parc de Sceaux, avril, 7 h. matin.* (1925)

have thus been difficult to get beneath the skin of, to the substance below. The tonal elegance of Ansel Adams's pictures and the balletic grace of Henri Cartier-Bresson's have misled many young photographers into thinking that elegance, or grace, was the beginning and end of it, and if they thought so they were badly served by their master of choice. But other young photographers have doubtless thought, mistakenly, that the meaning of the work of Walker Evans, or Eugène Atget, resided in their cool reticence of manner.

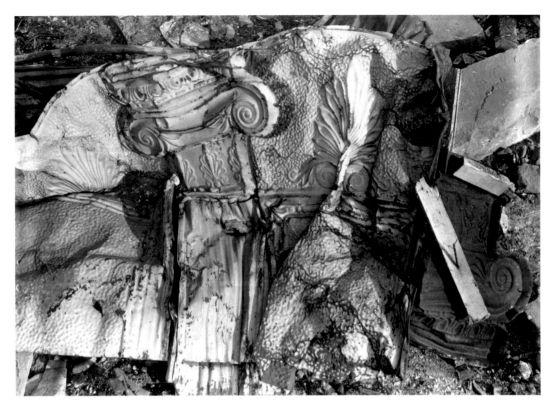

Walker Evans. *Stamped Tin Relic.* 1929

❧

To the degree that Atget was an artist, we must assume that his chief reward came from doing the work. He had the pleasure of solving (provisionally), or at least the pleasure of struggling with, problems more open-ended than the most esoteric chess problem, since the board could never be returned to its previous condition, and since the possible moves were not finite but infinite in number.

That also is to say that our appreciation of Atget is of no concern or value to him; it is of potential value only to us. If that appreciation is to be more than merely sentimental we must ask what remains in the work that we can make use of to improve the quality and range of our own photographs, poems, moral imaginations, or lives.

The answer must be in the pictures, not in words that attempt to describe the pictures; but without trying to describe them we might risk trying to name some of the qualities that reside in them.

The pictures are never quite what we would have expected. They are never quite perfectly resolved in their sentiment—contradictions are not edited out. They are disinterested—free of special pleading. They are brave—in the sense that (we feel sure) nothing is made to look either better or worse than it looked to the photographer. They are dead-on accurate—in the sense that they allow us to know that these scenes will never again look as they look in the pictures. They are as clear as good water, as plain and as nourishing as good bread.

❧

PLATES

❧

I t is known (widely agreed) that in his youth Eugène Atget worked briefly as a sailor, and then for perhaps a decade, but probably less, as a minor-league actor, before he turned (either suddenly or gradually) to photography, probably in the late eighteen eighties. After that he was a commercial photographer and occasionally an amateur actor, although he never called himself either of those things.

Atget is remembered chiefly as a photographer of Paris and its environs, but his earliest photographs are rural scenes—landscapes, botanical studies, and details of agricultural technology. Since he was a commercial photographer, we can assume that he made these photographs to sell. The most likely market for pictures such as *Terrain* would seem to have been painters and illustrators; in fact no other possibility suggests itself. At the end of the nineteenth century this picture would not have been used as an advertisement for the plow maker to show what a straight, broad, deep, and confident furrow could be plowed with his instrument. All of that came much later.

The field has been plowed very skillfully, just down to the top of the subsoil, and showing here and there a wafer of the damp clay that lay under the precious foot of leaf mold, rotted cow manure, and lowland muck that made France rich.

This picture was made near Limoges, near the center of France, and far from Bordeaux, where Atget grew up, and from Paris, to which he moved when he was twenty-one. The handful of pictures that Atget identified as having been made near Limoges are rural scenes that propose no obvious answer to the question of why he went there. It is a minor lacuna, among long lists of missing information about Atget.

Long before Atget entered what was surely a crowded line of work, most painters had accepted the fact that it was easier, quicker, cheaper, and more convenient to work from a photograph of a plowed field than to wait for the plowing season, then travel to the motif, and hope for good light.

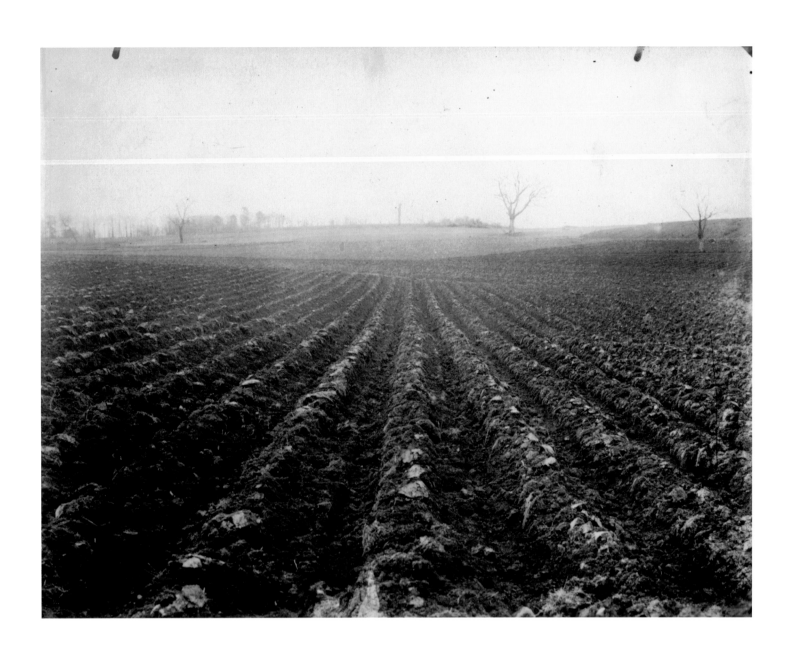

1. *Terrain (Limoges).* (before 1900)

Most of Atget's early pictures—like this one—were made in the north of France, where he seems to have lived in or near Abbeville, a port near the mouth of the Somme. It is possible that he might have first visited Abbeville during his years as a sailor. Abbeville was part of what had been the province of Picardy until the French Revolution, and the region was still popularly called Picardy in Atget's time, as in the popular ballad of the nineteen twenties, "Roses Are Blooming in Picardy," memorializing the 600,000 men who died there in the Battle of the Somme, in what later came to be called World War I.

The plow itself is a very interesting artifact. It appears to be a collage of parts that might span centuries: the wood beam and handles resemble those on the plow in Bruegel's painting of Icarus falling into the sea; the iron wheels and axle, married to wood hubs, are a little later; but the plowshare—the knife that cuts into the soil—and the mold board, which turns the furrow over, are new; they are part of the new age, and the sculptor Brancusi would have loved (surely did love) their unprecedented geometric beauty.

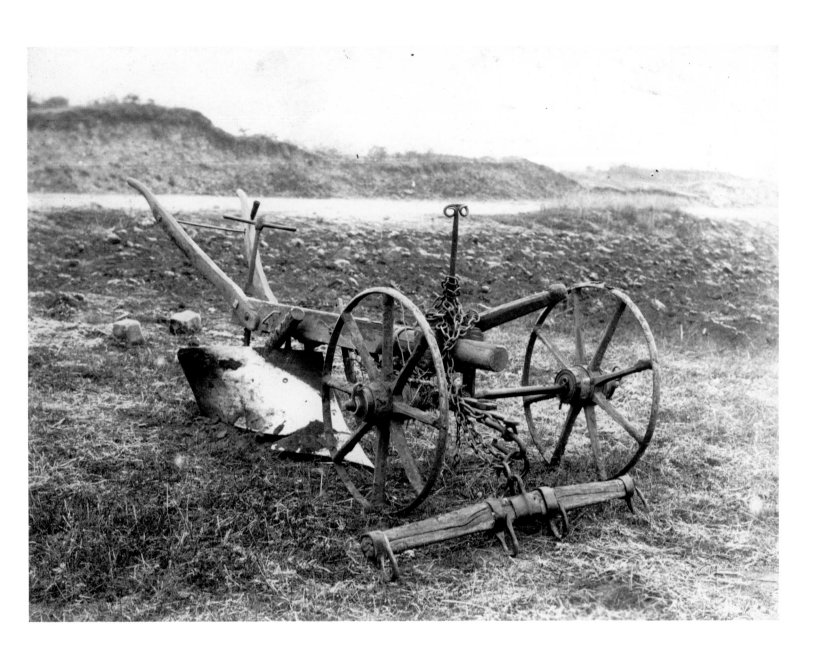

2. *Charrue.* (before 1900)

We do not know why Atget began his work as a photographer in the north of France, and we must therefore assume that it was a decision, like most human decisions, that was based on inadequate information, convenience, intuition, and contingency. It is probable that he learned the rudiments of his craft as an assistant to another photographer, and perhaps that photographer practiced in Abbeville.

In any event, we can be confident that Atget did not begin his career away from Paris because he felt that the experience might help him better comprehend the structure of French culture. Nevertheless, it is possible that by photographing in the countryside he did learn something about the basic sources of French character, and the French sense of personal authority. A half-century later Charles de Gaulle confessed that it was not easy to devise consensus in a country that made two hundred and sixty-five kinds of cheese.

The sunflower (like the tomato, the potato, and corn) is a native of the Western Hemisphere, but by Atget's time it was grown around the globe—for fodder, for oil, for yellow dye and compressed oil cake, for cattle and poultry. It is hard to know how France's finches had done without it in pre-Columbian times.

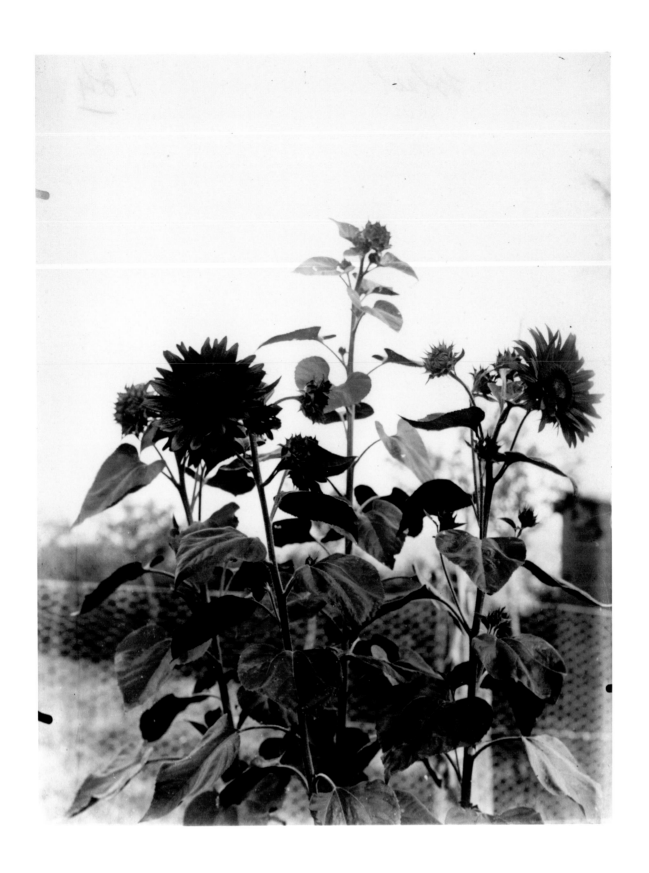

3. *Soleil.* (1896?)

Most of Atget's close-up studies of individual plants were done early in his career, when he was concentrating on making photographs that he could sell to painters and illustrators as cheap and easy substitutes for preparatory drawings. These customers did not want Atget's personal impression of a sunflower, for example, they wanted what we might call *good objective description*. They could later add whatever interpretation was needed.

In the beginning, to achieve this goal Atget would often drape a bed sheet behind the plant he was photographing. This technique provided a good objective description of the profile of the plant, which is what the painters wanted, or thought they wanted. (Nevertheless, these pictures give only a poor subjective notion of what the individual plant actually looks like *in situ*, and the sheet—a reflector—distorts the character of the light.) These pictures are unsatisfactory because they neither persuade us as naturalism nor divert us as artifice.

Surely they were unsatisfactory to Atget also, for he soon abandoned the practice, and found other ways to describe the profile of the plant, without sacrificing too many other truths. In his sunflowers (plate 3) he had set up very low in order to place the plant against the sky; sometimes he would find a vantage point that would place the specimen in sunlight, against a shadowed background, or the reverse; sometimes he would open the aperture of his lens to make the plant sharp and the background out of focus. Generally he found it best to avoid the sun, and work in the shade, or on gray days, as one would for sculpture, to avoid the complication of hard shadows.

His *Potiron* was made many years after the sunflower picture, and it is doubtful that he was still worrying about the priorities of painters and illustrators.

(*Potiron* means pumpkin, but it must be a different variety than the famous Halloween pumpkin, since it grows on a climbing vine. Perhaps it is a member of the genus *Cucurbita ovifera*, not *C. pepo*.)

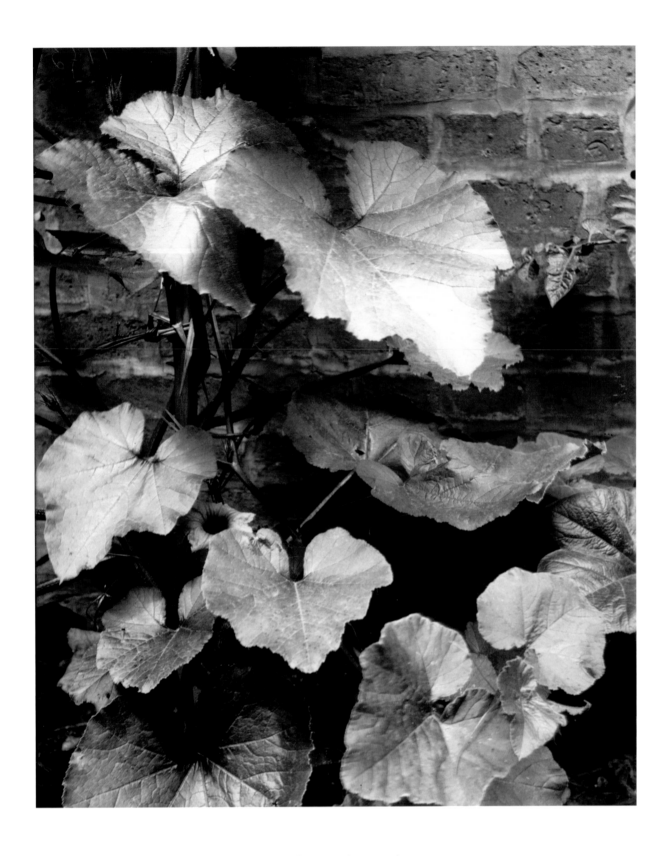

4. *Potiron.* (1922–23)

tget made relatively few pictures of people. Perhaps not two in one hundred of his pictures include people as significant players, and few of this two percent can be thought of as portraits, if a portrait is a picture that attempts to describe what is specific to a particular person. Most of Atget's pictures of people describe the role rather than the individual: they show the ragpicker, the street musician, the porter, the prostitute—not the specific souls who happen to serve those roles.

It might have been that Atget found the things that people make more interesting than their makers. Perhaps he formed this view during his years as an actor; on a good night the performance is surely more interesting than the performer.

Only rarely does one feel a mutual interest between Atget and his human subject. In all of his great oeuvre, there are fewer than a handful of pictures in which a person looks back at the photographer as though she (or he) knew him. Perhaps that is not altogether true; the ragpicker in plate 16 recognizes the photographer as his enemy, and the child (or midget) singer in plate 12 recognizes him as a potential publicist. But the woman of Verrières is different; one feels that this handsome, ample, competent, and possibly generous lady, and the photographer who was in the very act of immortalizing her, appreciated each other—if only for this instant.

Her sluggard, cigarette-smoking son in the doorway—only just young enough to have avoided the disastrous recent war—looks on with patent disapproval.

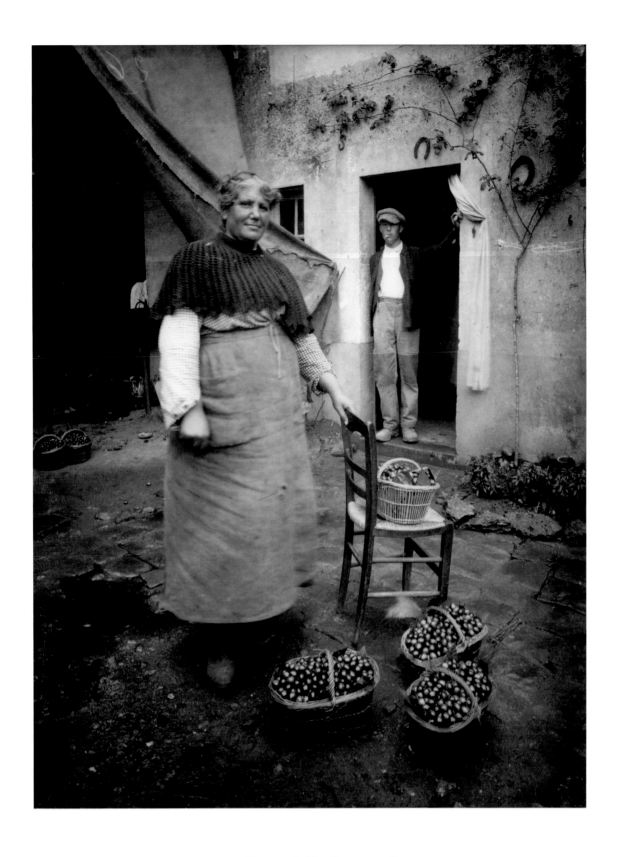

5. *Femme de Verrières.* (1922?)

The King James committee that devised the Bible with which we are most likely to have some familiarity worked from Greek and Hebrew texts that dated from a time when neither language seems to have had a word for apple. *Karpos* in Greek and *koré* in Hebrew mean only fruit. Nevertheless, by the early Renaissance the apple had clearly won out over the pomegranate, the apricot, and other early contenders for the honor of being the fruit that grew on the tree of knowledge. By the time of King James it surely ranked third, after only bread and wine, among foods with artistic and poetic resonance.

In the north of France, the apple has been almost as important as the grape in the south. It was not only the standard fall and winter fruit—for eating fresh, for applesauces and applebutters, for the fillings of winter pastries, and for pickling whole, with spices; it was also the source of fresh cider during the end of summer and autumn, and then hard cider, and finally, years later, apple brandy: the fermented, distilled, and aged essence of what had in its youth been only apple juice. If the tree grew in the right part of Normandy the distillate could be called Calvados, but it was doubtless also good in other neighborhoods.

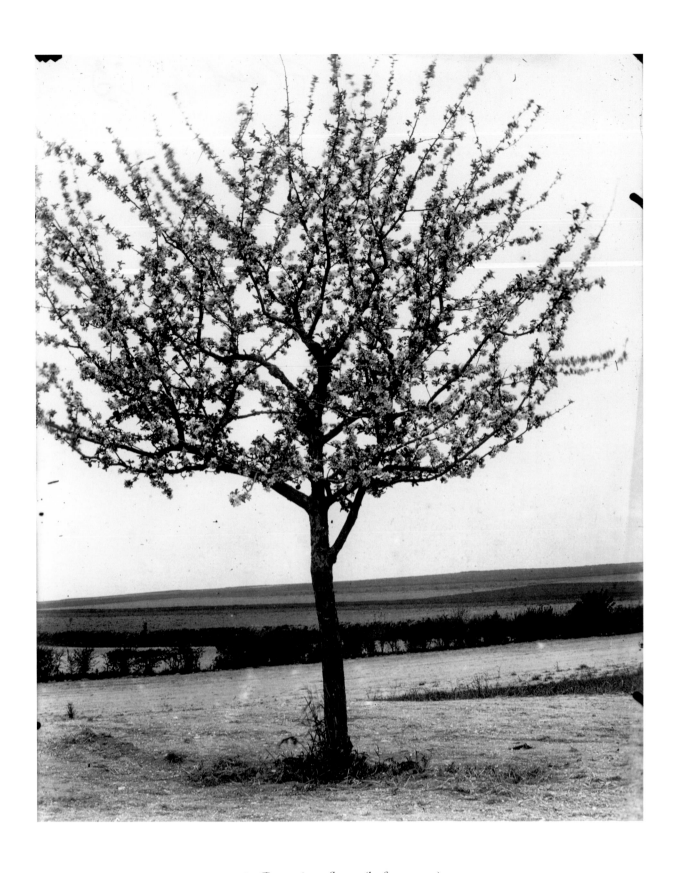

6. *Pommiers, fleurs.* (before 1900)

By the time we go to kindergarten we have learned to draw an apple tree in summer; it resembles a green lollipop on a thick brown stick. A little later we learn how to draw an apple tree in winter; here the green disk is replaced with a network of scratchy, angular branches—all elbows and knees. (This is a sound schematic rendering, which expresses the fact that an apple tree is only half an act of nature, and half the creature of constant pruning.)

Photographers are also in debt to the hard-earned conventions of representation, and for the most part their photographs of apple trees follow the models described above. Atget made many such beautiful photographs of apple trees, which he must have loved, and it was not until he was sixty-five that it came to him that apples are not fastened to an apple tree like Christmas ornaments on a dead spruce, or like campaign pins on a winter suit, but rather like trout on a fragile leader. They hang to the tree because they are given almost complete freedom by the slender, sinewy branches from which they depend.

Photography was by this time eighty-five years old and had made many excellent photographs of apple trees, but it is not clear that anyone before Atget put his back to the trunk of the tree and pointed his camera outward.

Actually, Alfred Stieglitz made a similar picture, looking outward from the tree and framing the apples in the gable of his house at Lake George. Stieglitz's picture is dated 1922, and Atget's was made in that year or the next. They might have been made on the same day.

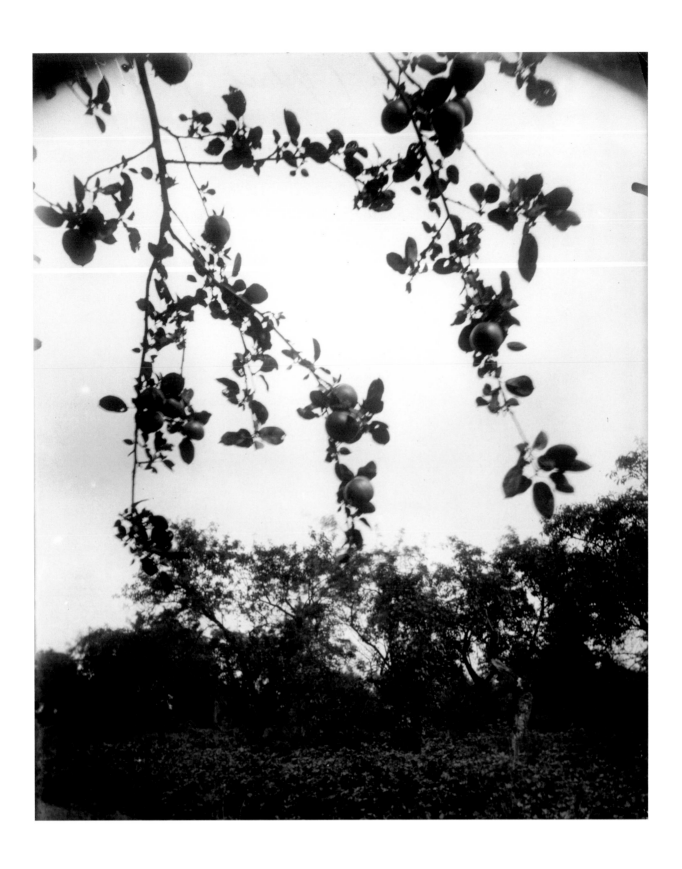

7. *Pommier (détail).* (1922–23)

It seems statistically unlikely that miraculous events (or even semimiraculous events) always occurred at the bases of the gnarled wrecks of ancient trees, but the documentary evidence would seem to suggest that this was the case.

Or possibly the ancient wreck of a tree was, at the time of the famous event, no more than a seedling, and perhaps it was five or ten meters one way or the other from the precise spot where the appearance or disappearance or healing actually occurred. Nevertheless, the young tree was the closest visual marker to the exact spot, and so it gradually *became* the exact spot—and a holy tree. At first it would be protected from the men who mowed the roadsides by a small wood fence, and finally as the significance of the tree became apparent beyond question to the entire community, it became encrusted with a masonry shroud of official appreciation.

This may have hastened the decline of a tree that was already diminished by the constant taking of sacred cuttings, but in the end it resulted in a tree that perfectly served the role that had been assigned to it. Not many painters have suggested better than this tree—at the far end of its tenure—the agony of Golgotha.

Shrines like this one were of potential interest to painters, especially genre painters, who might incorporate them into their pictures of Jeanne d'Arc.

The painters who were Atget's clients, however, might have wondered why Atget so often stood in the wrong spot, as in this case, where the tree not the shrine seems the chief subject and where, like some ancient horned druid, it seems to carry the shrine before it like a shield.

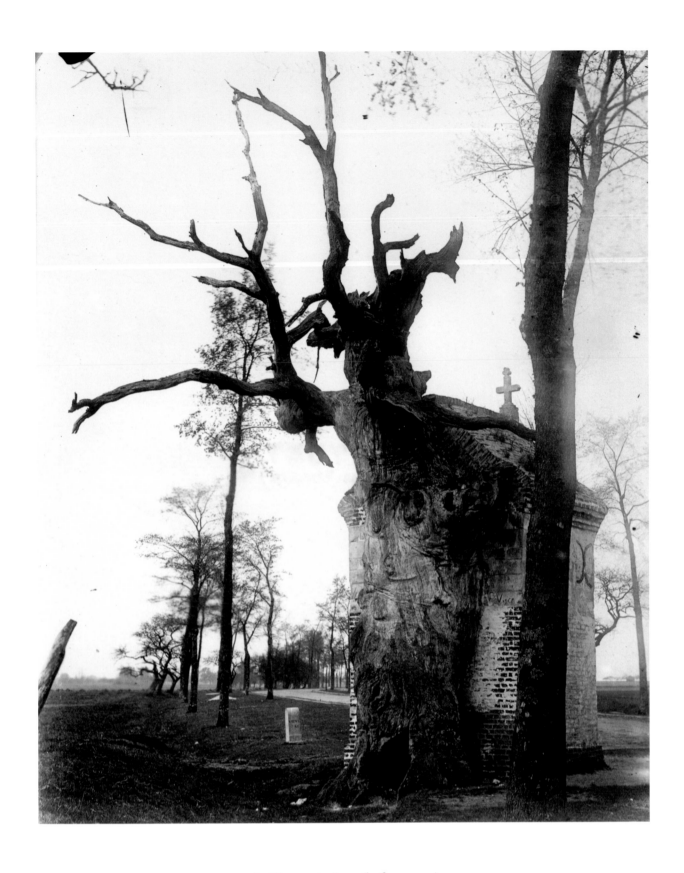

8. *Route, Amiens.* (before 1900)

Some trees are brought down by many years of excessive attention (plate 8), and others are destroyed in a moment, by a bolt of lightning in a late summer thunderstorm. We know it is late summer in this picture because the field of grain is partly uncut and partly already shocked. The shocks are distinctive: they seem constructed of two vertical tiers of bundles, the top tier serving as a kind of thatched roof for the lower. On the basis of the style of the shock, an expert in French agricultural technology of a century ago might be able to tell us the province in which the picture was made, since Atget did not note it on the print.

If Atget hoped to sell this picture to painters, it might be useful not only to a painter of thunderstorms but to a battle-scene specialist. George Barnard's photographs of Sherman's campaign of 1864–65 demonstrate that a tree broken by a cannon ball looks very much like one broken by lightning.

It has been said, in various ways by various writers, that photography is most at home with bad news. If there is a kernel of truth in this depressing accusation, it might relate to Tolstoy's outrageous calumny about happy families—that they are all alike, whereas each unhappy family is unique. The truth is that what we call happy families are not really alike, but art (unlike philosophy) does its work by citing the specific, rather than invoking general principles, and it does seem to be true that the specifics of bad news are easier to make use of artistically than the specifics of happiness.

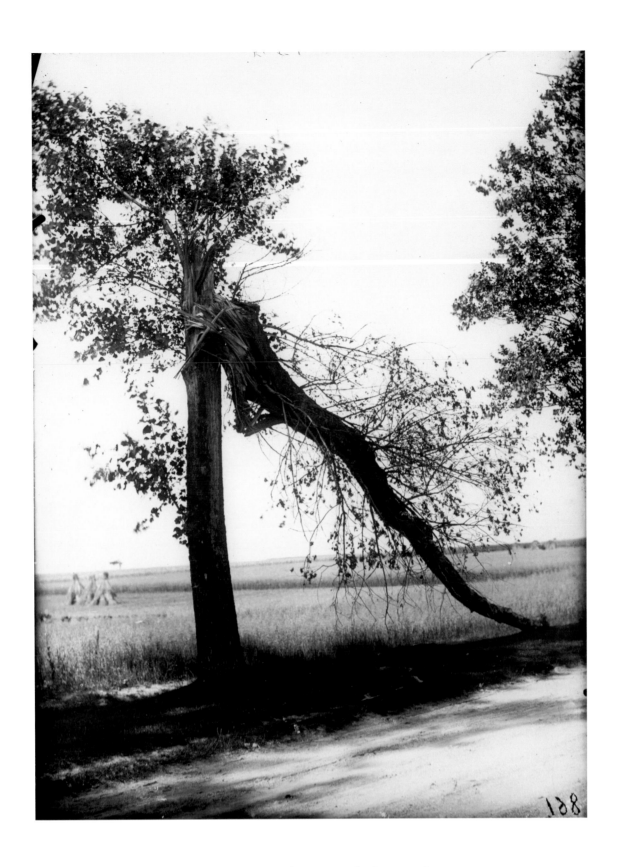

9. Untitled [broken tree]. (before 1900)

*B*utte-aux-cailles means "the ridge where the quail live," but it would not seem that there were many bobwhite (or their European cousins) on the part of the hill that Atget describes here. This was one of the places that marked the unofficial and shifting edge of the city, once it had escaped its ancient gates. The suburbs were farther out and the city closer in. This bit of the place has the surrealist charm of a prison: a path with no doorways, no signs of commerce, and no exits, except for the one at the end of the path.

The passage Vandrezanne was a narrow, shadowed canyon, but in Atget's print it seems full of light, and the subtly modulating patterns and textures of the canyon's walls and floor are described with an indiscriminate, compulsive, hypnotizing completeness. It is the kind of photographic description that is the result of extended development of the negative, which exaggerates (expands) subtle tonal distinctions. The negative would probably look shockingly dark and contrasty to a modern photographer, and it would be extremely hard to print well with modern photographic papers—even at the size of the negative, not to mention by enlargement. But Atget did not use modern photographic papers—not even those that were modern in his day—and he apparently thought his 18 x 24 centimeter plates (a little smaller than 8 x 10 inches) were big enough for his purposes.

The first young photographer to be deeply and permanently marked by the meaning of Atget's work was Berenice Abbott, an American who had first seen his prints at the studio of Man Ray, for whom she had briefly worked. Later she visited Atget at his own flat to buy prints and to learn what she could—through a substantial language barrier—of the compelling, opaque figure who had revised her sense of what photography might be.

On one of her visits (I think not the first), Atget invited her, after some extended conversation, to come with him into the darkroom, while he considered a plate that he was developing. She did so, and saw him take a single plate from the developing tray, view it against a red safelight, and then return it to the tray, after which the two photographers returned to their conversation. One is left with the impression that when Abbott finally left, the plate was still developing.

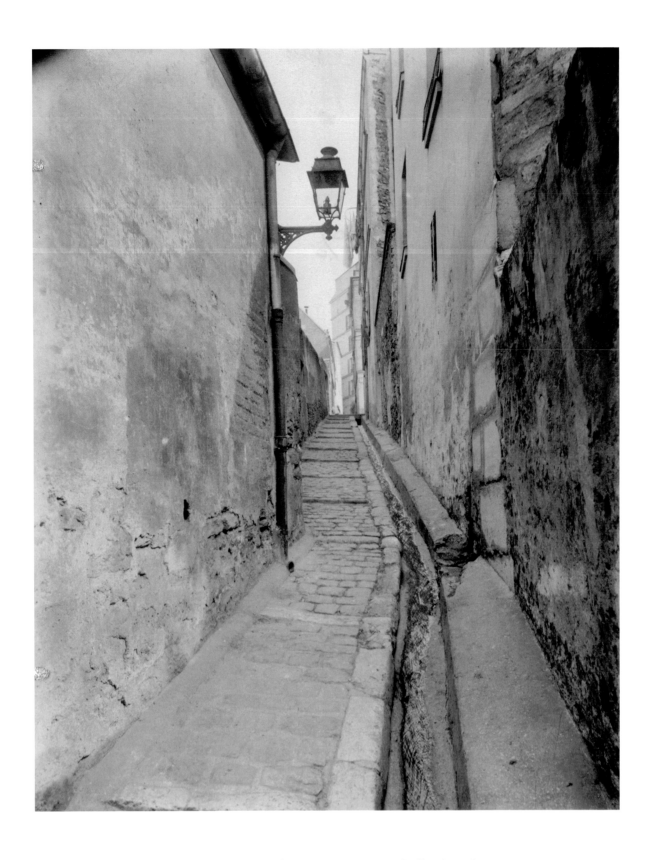

10. *Passage Vandrezanne, Butte-aux-Cailles.* (1900)

When Atget was a child his great predecessor Charles Marville was making extraordinary—magisterial—photographs of the streets of Old Paris with plates that were twice as big and probably twenty times slower than Atget's. Marville liked to work in the early morning, as did Atget; but even in midday, dirty buildings on the shady sides of narrow streets soak up light like black holes, and reflect almost none back to the camera.

In such circumstances, *very* long exposures were sometimes less of a problem than fairly long exposures. If Marville's exposure was (let us guess) a minute, then a walking horse pulling a wagon across the camera's field of view would not register, and the photograph would show an empty street. If the exposure had been five seconds, the horse would have had to gallop past in order to remain invisible. In such instances one hoped that the picture's incidental figures, its spear carriers, would move either rapidly or not at all.

In the case of this picture by Atget, one of the figures is a model of immobility. He seems to be watching a shorter figure—perhaps in a white blouse or shirt—who has walked past the dark doorway during the exposure. However, this is an illusion, unless perhaps he was following the figure with his eyes without moving his head.

The street was named for Abbot Suger of Saint-Denis, the great twelfth-century churchman who—as client and exhorter—was one of the important creators of the Gothic idea. Saint Bernard accused him of worldliness, but Suger answered (in effect) that the line between the corporeal and the spiritual is not always so clear as some saints might think.

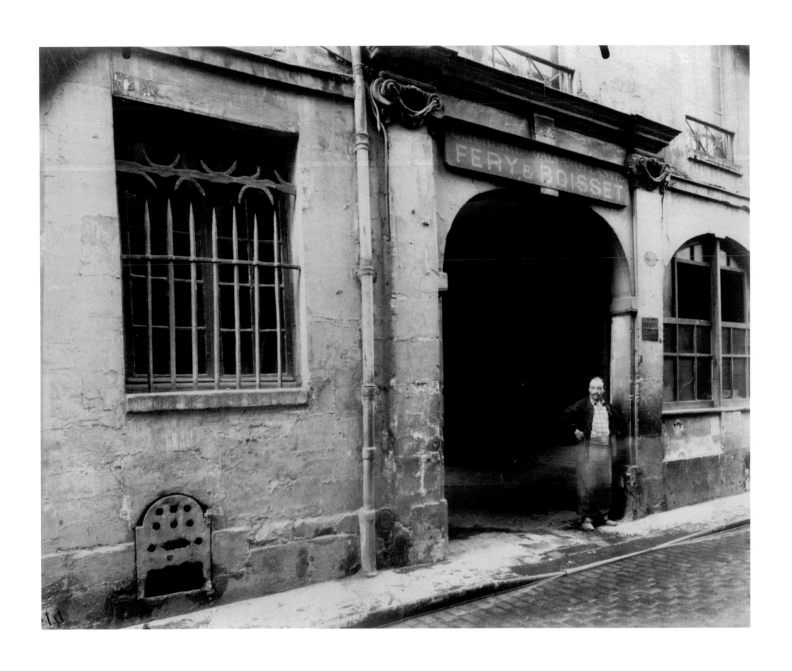

11. *Maison, 13 rue Suger.* (1900)

The instrument is often called a barrel organ, but *barrel piano* would be more accurate, since it is a percussion, not a wind, instrument. The winding of the crank turns a barrel into which pins have been set, which in turn trip the mechanisms that strike or pluck the strings. The musical clocks of the eighteenth century, for which the great classical composers wrote tunes, were based on the same principle.

This subject is one of at least fifty-five of the street trades, or *petits métiers,* which Atget photographed very early in his career in Paris. In Atget's cataloguing system these pictures were part of a much larger and diversified series called Picturesque Paris. But in 1910 he broke off a section of the whole and produced an album of some fifty sample prints titled *Paris pittoresque, petits métiers.* By Atget's time the artistic tradition of producing typological pictures of the street trades was already ancient and had been continued in nineteenth-century France by artists such as Paul Gavarni and Théophile Steinlen. We know that Atget knew Gavarni's work, since he made photographic copies of some of his drawings; but it was not necessary for him to have known.

In what were perhaps preliminary notes for his splendid captions for a 1948 Atget exhibition at the Addison gallery in Andover, Massachusetts, Ferdinand Reyher said: "Nowhere is there a laugh in Atget. There's no glossing of dreariness with spurious jollity . . . no laugh that hides, no pictorialization of the condoning proverbs, such as Sweet Are the Uses of Adversity, or any of the slave phrases and horrible submissiveness of the silver lining."

The beaming face of the singer in this picture might seem to contradict Reyher's view. We might well believe that what we see is spurious jollity glossing the dreariness of her life. On the other hand, she is a professional entertainer, even if one of low rank, and as such her radiant smile (as fine as that of the more famous chanteuse Yvette Guilbert, in the great Steichen portrait) is not evidence of ordinary insincerity, but of art.

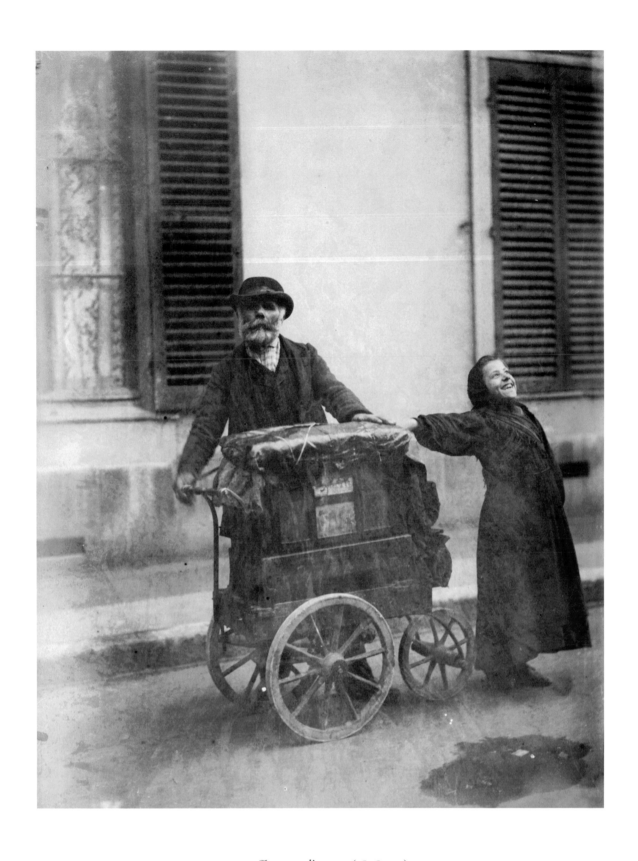

12. *Joueur d'orgue.* (1898–99)

A subject like this is a very attractive proposition for a commercial photographer, because of the potential residuals. One might in the beginning have made the picture for an architect or a fabricator of doors or a sculptor or an *amateur* of Old Paris or an official archive, but the photographer was probably confident that he would sell prints from this negative many times. Perhaps he even sold a print to the now diminished Archbishop of Lyon, as a souvenir of the style in which his predecessors had, in the old days, lived when visiting the capital.

If this were the case one might well take some extra care to get the picture right, and even to scout out the conditions under which the subject might best be photographed. It wants a soft but not totally diffused light, and one that reaches far enough in under the deep reveal of the door frame to describe the monogram held by the two *putti*, which was surely of greater interest to many of Atget's customers than it is to most of us.

Except for the architects, Atget's clients would probably have been equally happy with the picture if the right-hand door had been closed. Nevertheless, both Atget and his competitors often left one door open—perhaps because the concierge insisted, or demanded a gratuity to close it. But once left open, for whatever reason, the doorway becomes a picture within a picture—part of the whole and yet with an independent life of its own, like the landscape in the window of a fifteenth-century interior.

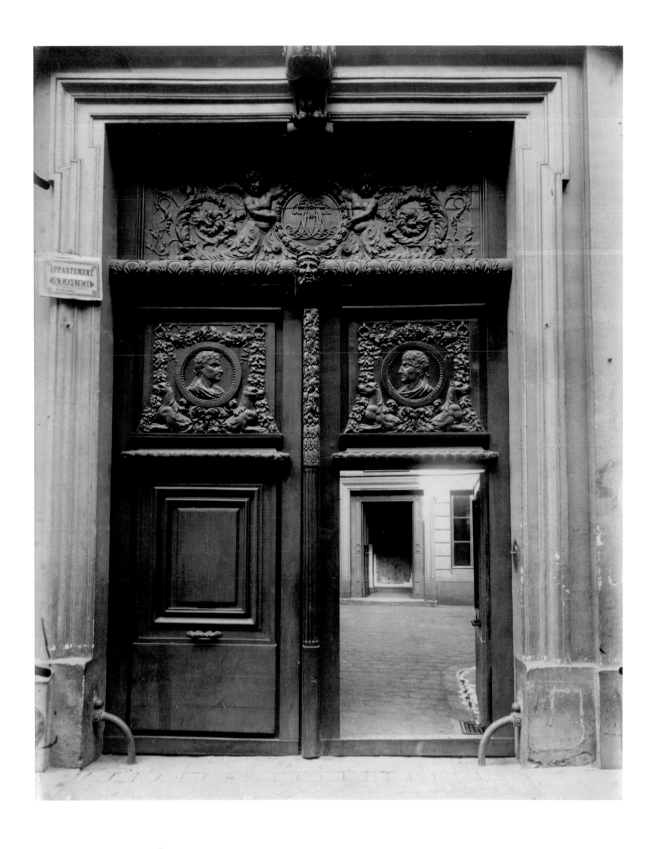

13. *Hôtel des Archevêques de Lyon, rue Saint-André-des-Arts, 58.* (1900)

tget's caption tells us that this picture was made at the farm of Camille Desmoulins, one of the most famous of the long line of literary politicians, or political men of letters, for whom France has been distinguished. His career was unhappily shorter than that of Malraux, or Sartre. He became famous for his anti-royalist speech of July 12, 1789, which is said to have been so persuasive that it led to (or helped lead to) the storming of the Bastille two days later. In 1794, only five years later, after many political changes, he was guillotined with fourteen others, including the revolutionary Danton. Atget was apparently a man of the left, and would naturally have had sympathetic feelings for Desmoulins, and perhaps also for his executioners, who were also men of the left.

If this picture had come to light without a negative number, but known to be by Atget, I would with confidence have said that it was a picture made after the Great War—because of its extraordinary formal elegance. In fact, it was made when Atget was not yet forty-five, when pictures as surprising as this did not happen every day.

14. *Bourg-la-Reine, ferme Camille Desmoulins.* 1901

To a photographer the world consists of an infinite number of vantage points—places to stand—of which very few are altogether satisfactory. The photographer's goal is simple in principle and seemingly modest in ambition: it is to find the place and moment from which some interesting aspect of the world can be converted into a photograph that will be both clear and lively.

Alas, when we remove from the world its space, texture, smell, temperature, sound, and often color, the aspect that remains is seldom either clear or lively. We aim for clarity and generally get stasis; we hope for liveliness and too often get what is merely messy.

Nevertheless, occasionally photographs are made that are good to look at and unfamiliar (clear and lively), and from those pictures we may learn something. For example, a cluster of ellipses in a corner (like a clutch of eggs in a nest) may define an architectural space, and if the skin of the niche (like the wall of the nest) has a coherent, articulated surface, that is good both for clarity and liveliness. If the picture seems too secure, one can pan the camera a little to the left, and open up an escape into the unfamiliar distance, and danger.

Such occasional small blessings accumulate in a photographer's mind, not in a form conscious enough to be called ideas, except in the most inchoate form, but as a growing awareness of the pictorial possibilities of the world—of some of the ways in which the visual data of the world form clusters—that can be recognized in very different circumstances.

This picture and plate 14 were both made early in 1901. Because Atget numbered them in two different parts of his file—one under Paris and one under Environs—it cannot be said which came first. One might note that plate 14 does not have the escape into deep space, but it does have a door.

There were good, or at least understandable, reasons why the French might have changed the name of rue Beethoven in 1870 or in 1914–18 or in 1939–45, but it is surprising that there is no such street listed in the Baedeker of 1904.

15. *Cour, rue Beethoven, 9.* (1901)

Atget's first identifiable class of customers were painters, and it might be supposed that what they wanted from a photograph was not art but fact. A photograph could be a great help with certain kinds of visual facts, for example, with the ways that clothes drape and take the light, with the way that the round bill of a cap can throw a straight shadow, and with very difficult perspective problems, such as the correct drawing of complex shapes (perhaps baskets) seen from unfamiliar vantage points.

Atget began his series on the street trades in 1898 or 1899, and it was finished by 1900. It seems that the series originally contained at least 135 plates. In about 1905 Atget apparently sold eighty of his negatives—his rejects, I believe—to the publisher Victor Porcher, who made from them a series of photomechanically reproduced postcards. In about 1910 Atget assembled a paper album of approximately fifty-five prints that represented his own view of what the series amounted to.

Most often the kinds of subject matter that Atget addressed early in his life as a photographer he continued to pursue into his last years, but the *petits-métiers* idea was abandoned permanently in 1900. After that date Atget made very few pictures of people. The rare exceptions, such as the *Femme de Verrières* (plate 5), seem portraits of specific people rather than patterns for representative types.

The street-trades series was done quickly and, it would seem, without a great deal of philosophical heavy lifting. The subject's role was satisfactorily defined by clothes, wares, equipment, and generally a posture of servility. The paper seller, the flower seller, and the window washer were all done on the same corner, from the same camera position, and almost surely on the same morning. Atget was simply applying his method. A few yards down the street, perhaps again on the same day, he applied his system again and made the picture of the ragpicker. The photographer was technically competent, alert, brave enough not to be brought to his knees by the well-earned hatred in the eyes of the ragpicker, and lucky; and he was therefore rewarded with a clear picture of a man who is hauling in his cart the dirty linen of the whole world.

16. Untitled [ragpicker]. (1899–1900)

Atget's lens was informally called a *trousse*, a word with many meanings, including "a case of instruments," "a quiver of arrows," or in photography a set of lenses that can be screwed into the front and back of the brass lens mount in various configurations to provide lenses of longer or shorter focal length. This means that from a given vantage point the lens will include either less or more of what is in front of the camera. Atget normally used his lens in a configuration that produced what was, for the time, an unusually short (or wide-angle) lens. On occasion, for reasons that are not always clear, he used a much longer lens, what we might (incorrectly but usefully) call a telephoto lens. He used such a lens for almost all of his *petits-métiers* pictures (such as the ragpicker and the basket seller in plates 16 and 18) but not for the picture of the lamp-shade seller. The difference is quite dramatic: the camera is oriented horizontally (otherwise the verticals would converge), and the lens is level with the top of the darkest lamp shade, yet we are looking down almost vertically at the man's right foot!

Perhaps Atget generally used the long lens for this series because a painter friend told him that they would provide a "truer" drawing of the figure, free from the "distortions" that were so common to photography. In a sense this is true: the greater the distance from which we view (or photograph) a subject, the more closely the visual proportions of its various parts will match the proportions that we would measure with a tape. If we viewed this subject from an *infinite* distance the sides of the street would not converge. We would then have something approaching an isometric drawing, which would not look true at all.

Jean-Auguste-Dominique Ingres, who drew his models from a considerable distance, would have had no use for Atget's lamp-shade seller, but it would not have surprised Cézanne, who often worked very close to his subject.

17. *Marchand abat-jours.* (1899–1900)

In the first decade of the twentieth century, Thomas Okey, Examiner in Basket Work for the City of London Guilds and Institute, wrote that the importance of basket weaving is in inverse ratio to a people's industrial development. This bold thesis was proved true a half-century later by the invention—by the most advanced industrial country—of the polyethylene bag.

Okey also pointed out that the basket is the mother of the arts of weaving and pottery, and the close ancestor of such crafts as the canoe and the kayak. He might have added the airplane, or at least the glider. He also noted that no machinery was used in basket making and that an expert workman needed both training and natural talent, the latter in order to conceive a perfect formal unity of shape and texture—to previsualize the finished basket—before beginning to work.

Even before the polyethylene bag, other jackleg shortcuts were casting a shadow over the art of the basket. Between 1900 and 1905 the exports of French baskets to the United Kingdom had fallen by half—to a mere 28,000 pounds.

Either the *marchand* or the photographer was in a hurry; even in the bright sun Atget is shooting at a very large lens opening, and consequently the background is very unsharp. The effect is intensified by the fact that Atget is standing farther from his subject than normally, and thus using a longer focal-length lens. Compare this picture with plate 17 for drawing and for depth of sharpness.

I have long thought of this subject as a basket maker who has brought his work in from one of the outlying quarters, but on reflection this must be incorrect; he is merely a hawker, working for some small capitalist with a shop within walking distance, for he could not have gotten his load in from the suburbs. The Paris Métro opened for business at about this time, but one cannot believe that the system could have handled this customer.

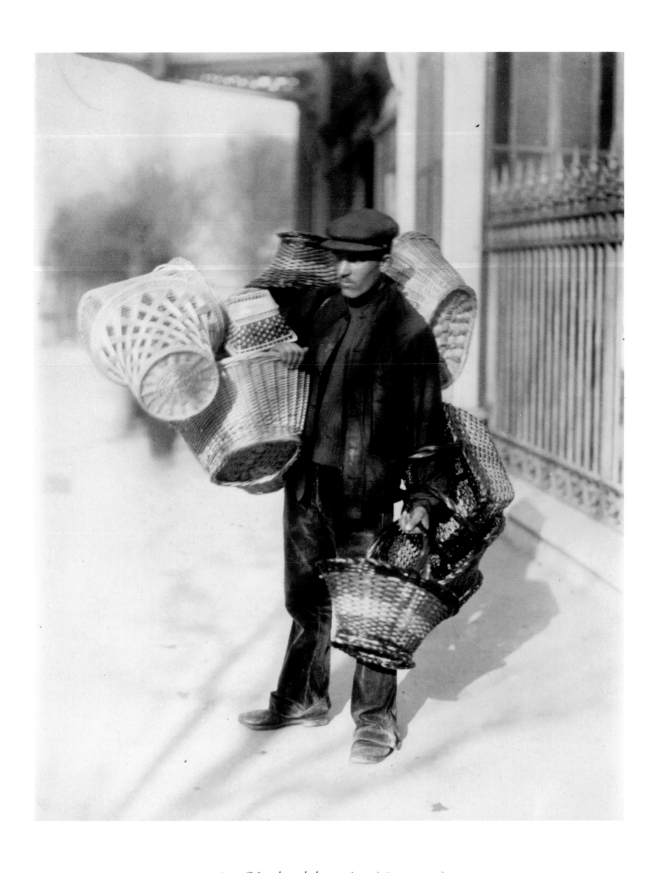

18. *Marchand de paniers.* (1899–1900)

Atget was forty, or a little older, when he decided to be a photographic specialist in the documentation of Old Paris. At this point he had almost no file of negatives, no partner or useful friends, little money, and very little experience in his new specialty.

Of these various impressive handicaps he might well have considered the most important the lack of a file of negatives, and he set about to correct that handicap with great energy. During his first years in the Old Paris trade he haunted the old quarters, photographing (it would seem) every old building, old court, and old doorway that he found in the antiquarians' books.

Many of these pictures are ordinary, and more than a few are less than ordinary. But he built a file, so that more and more often he could say yes, I have that one; would you like both the general view and the entrance detail? He formed a file, established a clientele, and survived.

But though we are grateful for his survival, what we really want to know is how he educated himself, how he transformed himself from a talented, half-trained, intelligent, ambitious free lance into the historic Atget—one of a tiny handful of the greatest photographers.

I think that part of the answer is that he educated himself by working continuously and rapidly, and by not saying no to problems that were too difficult for him, and perhaps even too difficult for what was understood of the medium. He accepted difficult problems one after the other, without too much analysis or questioning, thus permitting himself to learn that there were many ways to fail and that some of them were very instructive, and also that there were ways to succeed that he would not have dreamed of.

An entirely professional photographer would not have attempted this photograph. It is technically difficult, and it is not what the customer wanted. And the customer was right; this picture does not fit the type. It makes it difficult to compare this doorway with other doorways of the same period or the same designer. The customer wanted a simple elevation view, showing such details as the divisions of the plane and the character of the ornament; he did not want a cubist projection, showing in one picture both the elevation and a section through the plan.

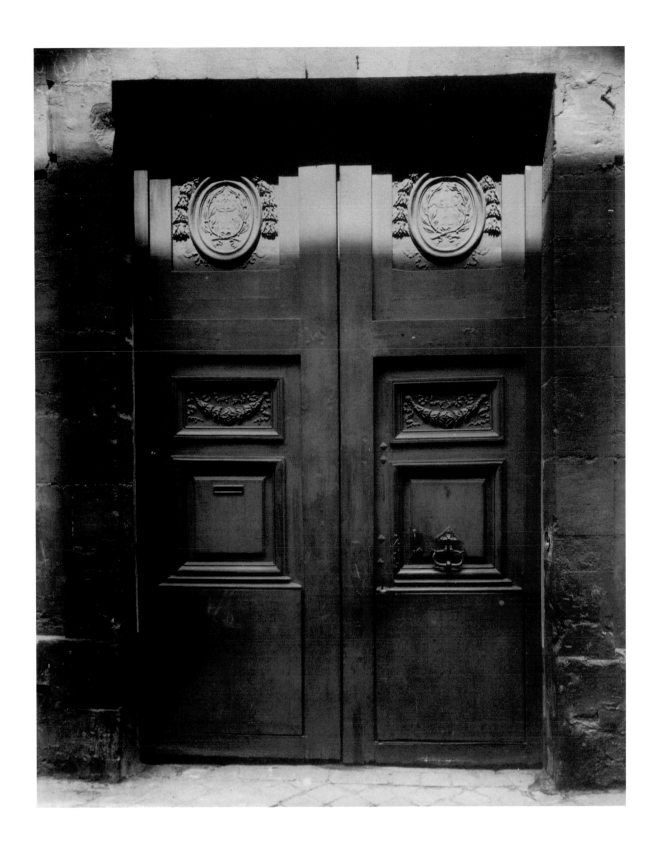

19. *3, rue Poulletier.* (1905–06)

T he technological component of the door-knocker problem was solved long ago, allowing subsequent designers to concentrate exclusively on expressive, ornamental, and symbolic issues. (The technical problem of casting is of course too complex ever to be finally solved, but that problem is not specific to door knockers.)

This knocker was on the door of a mid-seventeenth-century house that stood next to that of Jean-Baptiste Colbert, the economic genius and great tax collector who managed for decades to find the money even for Louis XIV's endless wars and gardens. In that neighborhood, this knocker rapped on a door of consequence. The head of this knocker has been called a skull, but it would seem to have its eyes closed, which would be incompatible with a skull, and it also seems to be winged. It looks to me like a winged lion, or perhaps a hippogriff—half horse and half griffin. The griffin was famous as a guardian of various valuable things, including gold and the road to salvation, and it would have been useful to have his image at the door to give fair warning to those who sought entry from the wrong motives.

The Museum's Atget collection contains many door-knocker pictures, but they must represent only a small fraction of those that Atget made, since libraries of design and craftsmen who specialized in decorative metalwork would have had an unquenchable appetite for such material. Many of Atget's door knockers are routine, but many others are deeply satisfying, for reasons difficult to define. This one is irresistible in its liquid gray light, and its hippogriff head polished smooth as satin by a quarter-millennium of hands.

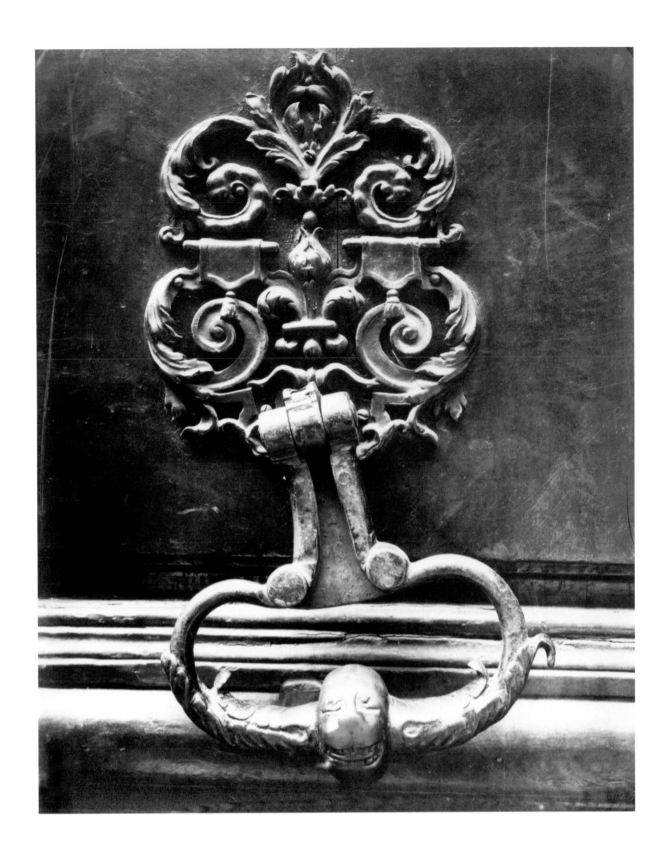

20. *5, rue de Mail.* (1908)

Vitruvius, the founder of architectural criticism, favored simple forms and restraint in ornament, and was especially severe in his commentary on buildings that appeared to aspire to the condition of plants. Most subsequent critics have agreed that rationality and restraint are good things. These are, however, relative terms: even the Austrian embassy was restrained and rational in comparison with high rococo design as it came to be practiced elsewhere—back home in Vienna, for example.

The point is that Vitruvius's belief might not have served him well had he been a photographer. The judgment is abstract, intellectual, and a priori, and thus stands as a barrier before the photographer's most basic ambition, which is to see first and theorize later. (This is only half of the truth, but perhaps enough for now.)

In any case, Atget was apparently deeply delighted with this room, managed to find a view of it that intensifies its riotous activity, and produced a picture in which no segment bigger than a man's hand is at rest, where every detail, like Jack's beanstalk, threatens to block out the sky.

The only sober note in the picture is Atget's camera, covered with what would appear to be an extra-large focusing cloth. Or perhaps it only seems large because he has placed his camera so low, not even hip-high, so that he could get reflected in the mirrors both the shape of the sofa and the ornament of the wall behind him. When Atget's camera is reflected in the windows of bistros (plate 26) we generally get a shadowy image of Atget also, but here his exposure is long enough to allow him to walk away from the camera and leave no trace.

The Hôtel Matignon, built by Jean Courtonne in about 1721, was in fact the Austrian embassy only from 1888 to 1914—rather briefly, in the scale of its long life. After the war it was not returned to the recent enemy.

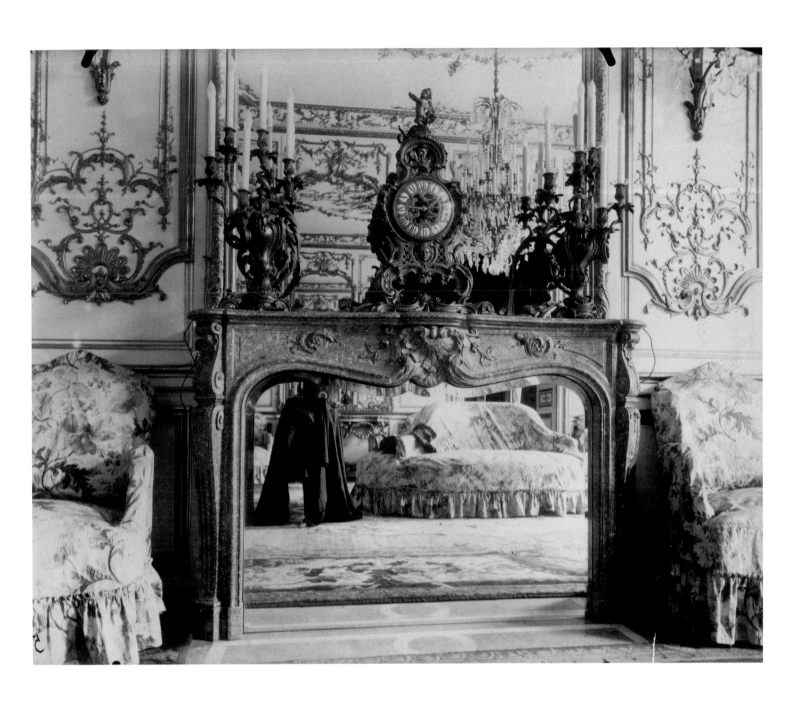

21. *Ambassade d'Autriche, 57 rue de Varenne.* (1905)

Although the evidence is scant, it seems reasonably clear that Atget was in regard to religion a free-thinker, and in politics a man of the left. Yet the nature of his work required that he describe—and in effect commend—the products of a culture that was resolutely Catholic and royalist. This would seem to constitute a serious artistic problem. It should not be compared with the distant, theoretical problem that might exist had Atget, a democrat, admired the Acropolis, even though the ancient Greeks held slaves, for the ancient Greeks did not vote in the Third Republic, and in any case slavery was not at issue.

Royalism and Catholicism were however very real issues in early twentieth-century France, and if we had no knowledge at all of Atget's private life it would be reasonable, I think, to assume that he was an apologist for the *ancien régime*. In some degree he *was* an apologist for the old dispensation. The beauty and the sympathy of his pictures establish this, whatever his intentions might have been. But he was also other things.

The noted Atget scholar Molly Nesbit—if I read her correctly—has seen in Atget's work, or in what she regards as the best or most important of it, a coherent statement centrally concerned with describing the prevalence and power of the class system during Atget's time. Certainly his project provides excellent data on the issue of class. Given the breadth and depth of his attention, this would seem almost inevitable. And if one defines *class* so broadly that it subsumes the whole spectrum of human concerns, then one might agree that Atget's work is about class.

But surely John Fraser came closer to the spirit of the work when he spoke of Atget's "continual voracious interest, curiosity, wholly unsentimental love and respect for so many different forms of existence, his Rembrandtesque ability to treat in exactly the same spirit the conventionally beautiful and the conventionally sordid."

In fact, photography—except in its murkiest, most evasive moods—does not lend itself easily to easy simplifications. At the end of a century in which endless bloody grief has been caused by blind obedience to principle, we are grateful to Atget's pictures partly because they give us a world full of lively contradiction, in which the potentials of chaos are not wholly foreclosed, and a multiplicity of small truths has not been homogenized.

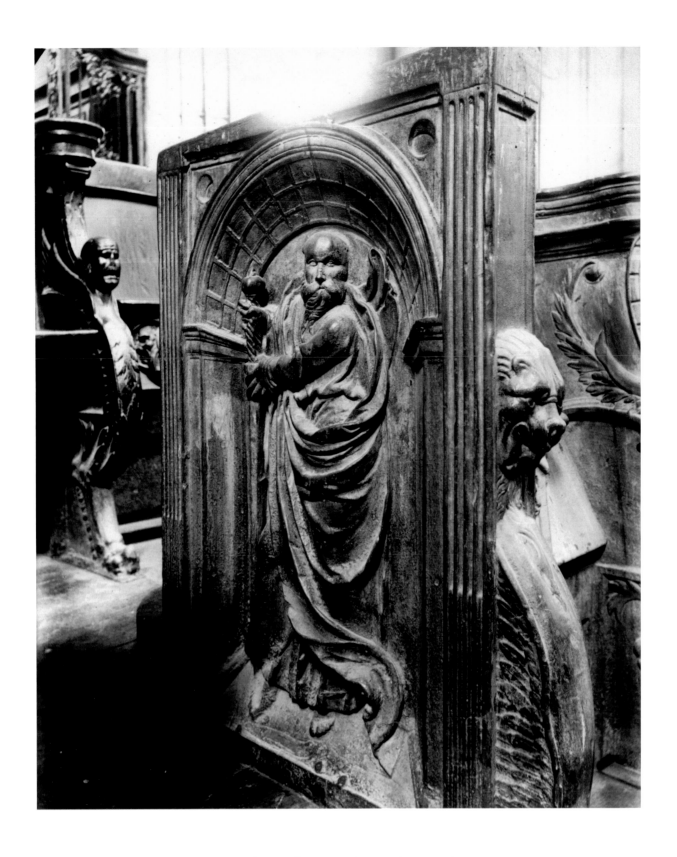

22. *Saints-Gervais-et-Protais.* (1904–05)

If this is indeed the house where Voltaire died, it is now 27, quai Voltaire; but it had of course a different name while Voltaire lived. In 1778 it was the house of the Marquis de Villette, and Voltaire did rather little there except to celebrate the success of his new play *Irène*, and die. The governments of Louis XV and Louis XVI found Voltaire a problem for reasons sometimes of substance and almost always of style. Before he was twenty-five he had twice spent time in the Bastille, although for a total of only about a year. Much of the rest of his long life he spent in semi-official exile, outside France, or just inside her boundaries, from which point he could quickly retire to Switzerland if the king became aggressive. When he returned to Paris in 1778, with the king's consent, and to great acclaim, he had not seen the capital in twenty-eight years.

If Voltaire did die in this house, it was probably substantially remodeled sometime in the century before Atget photographed it. The neo-Egyptian style in European architecture did not arise until after Napoleon's 1798 campaign in Egypt, from which he returned with the traditional trophies. These gave the architects a new closet of costumes to play with.

The copy of the Old Kingdom dignitary standing in the rear of the court presented Atget with an interesting problem, and an interesting set of options. If he had moved one full pace to his left he could have made the whole statue visible, but his lens would no longer have been on the central axis of the doorway, which would have annoyed his architect and archivist customers. Or, he could have used a wider angle lens (a different arrangement of his convertible lens), moved closer to the doorway, and gotten the whole statue by moving only very slightly to the left. (One can see more through a keyhole as one gets closer.) This solution would make the statue smaller in relation to the door. It would also put Atget in the middle of the quai Voltaire in midday traffic. Atget chose the solution seen here. Perhaps he liked the Whistlerian design of the picture in the open doorway.

23. *Maison où mourot Voltaire.* (1909)

It was perhaps an advantage to Atget—as an artist—that the various classes of his commercial clients and customers had clearly different concerns. Thus, when photographing a stair railing, for example, he need not decide whether he was working for a painter, a designer or fabricator of ironwork, an *amateur* of Old Paris, or a museum; he could explore his subject for what it yielded, and sell his prints later to those who could profit from them.

This picture of the staircase at 91, rue de Turenne could hardly have been of much use to an ironworker who wanted to duplicate it. In fact, a pattern maker would probably have had difficulty making useful drawings of these compound curves from *any* photograph, but Atget surely made the problem worse by photographing the stair from a vantage point that foreshortens its forms so severely—piling one shape on another so that the subject comes to resemble, perhaps, a serpent entwined in a tree.

The picture draws our attention to what is concealed (as in plate 23): who or what is hidden on the stair, behind the wall. Our own vantage point is not quite innocent; like a thief, we are hugging the right-hand wall, ready to peer around the corner to see if the coast is clear.

The picture would not be helpful to the pattern maker, but would surely be suggestive to a painter, especially one with a taste for the mystery of things hidden from view, and for the slippery, fugitive distinctions that separate the mineral and animal worlds. Man Ray was such a painter, and also a neighbor of Atget and a collector of his prints. In 1926 he acquired the picture shown here, and three others, for reproduction in the magazine *La Révolution surréaliste.*

24. *91, rue de Turenne.* (1911)

Most of Atget's customers who might have bought this print were specifically interested in its upper half. Some in fact might have been sufficiently insensitive to ask Atget to make the picture again, including only the important part. In such cases, Atget would return to his studio, pin the rejected print to an ancient drawing board, and rephotograph its upper half.

Copy negatives have always been, and remain, a very difficult technical problem, and even at their best they are seldom wholly satisfactory. Atget's copy negatives however are exceptional: they are unusually bad, and the prints he made from them are grainy, unsharp, and tonally lumpy. Even considering the limitations of his equipment, he should have been able to do better than he did for those customers who did not understand that he had made the photograph correctly the first time.

Copy negatives, used for the purpose of revising the photographer's original decision, served at the turn of the century the function now served by enlargers, which were at the time rare and primitive. The quality of the image that early enlargers produced was perhaps good enough for art photography, but not good enough for commercial work, where the customer expected clear description.

If one had only the top half of this picture one would have lost the complex nest of rectangles in which the *enseigne* sits so happily—dozens of real and virtual rectangles, all flirting with but not quite matching the proportion of Atget's 18 x 24 centimeter plate (with its 3, 4, 5 triangle), as well as the famous golden section (in which the short side of the rectangle is to the long side as the long side is to the sum of both sides) and the magical iso-rectangle (which, however often it is divided in two on its long side, retains the same proportion).

One would have missed also the contingent self-portrait or, rather, the two self-portraits: the large, dark, vague reflection in the glass of the door and the small bright one in the mirror in the back of the room. The mirror also repeats the masonry arch that was covered when the ironwork screen was added.

25. Enseigne, quai de Bourbon, 38. (1901–02)

By the early years of the twentieth century considerable antiquarian interest had developed in the old signs that had identified shops in the days when literacy was rare, and systematic methods for place location were not yet conceived. These emblems became of interest to the *amateurs* of Old Paris after they had largely disappeared, with the replacement of the old city by Baron Haussmann's new one. Many of those that had survived were found over the doors of bars, since they were often attached to the window grilles required by law for certain classes of establishment that sold liquor. Whether the ironwork was intended to keep the rowdyism and ribaldry outside or inside is not altogether clear.

Atget had made photographs of similar subjects since 1899, and by the next year he had evolved a more-or-less standard solution, planting his camera centered on the door, straight-on and close-up, and most often working on the shady side of the street or on a gray day, so that the forms of the sculpture and grillwork would not be obscured by hard shadows. (Plate 25 is only partially an exception; the sunlight that day was thin and watery, diffused by thin clouds, and the shadows it cast are open and transparent.)

Members of the staff, or customers, often appear in these pictures, peering out the door at the photographer who has set up his camera in the middle of the sidewalk. They do not seem to regard him as an *habitué*, and probably he was not. Atget was apparently something of a food crank; when away from home he seems to have lunched on bread and milk, not on veal Marengo, cod with whitebait, or lentils with something (doubtless something irresistibly delicious), which seem to be among the dishes written in chalk on the menu.

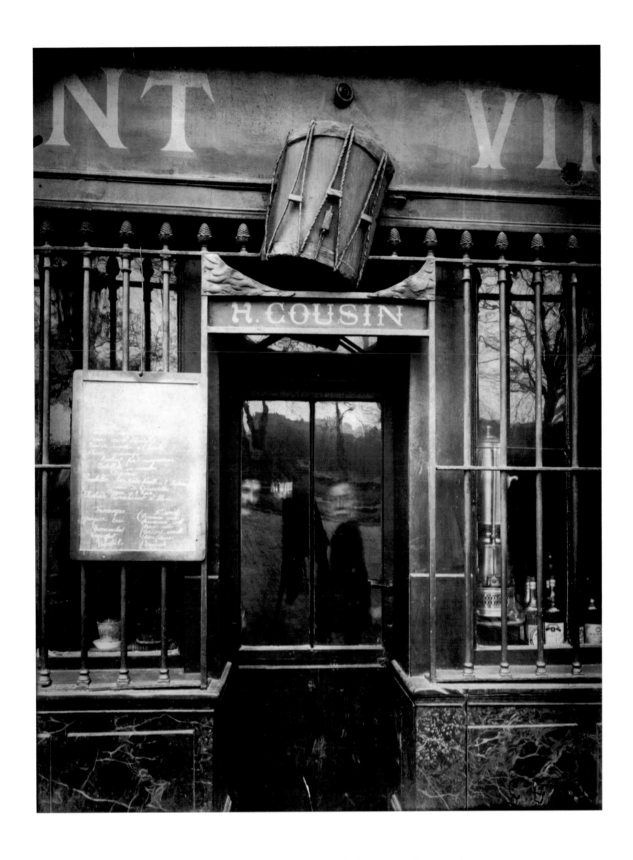

26. *Au Tambour, 63 quai de la Tournelle.* (1908)

The caption for this picture may have been designed to assure the potential buyer that he was getting what he wanted—a photograph of a rare old wrought-iron balcony. Without it, the customer might have been excused for thinking that he was buying a photograph of a shoemaker's shop, with the shoemaker's wares hanging in front, as elegant as waxed ducks in a Chinese market.

They are new shoes, too straight in the sole to be repairs, but if they were made to order they would presumably not be hung out to attract customers. The shoemaker has made at least eighteen pairs on speculation, and now must worry whether customers with the right size feet will come to buy them. If his grandfather was a shoemaker he made shoes by hand and to measure, and doubtless had no inventory at all, except perhaps for a pair or two intended for customers who had suffered financial reverses, and had not come to redeem their orders. But shoemaking machines had changed the business. An idle machine is a reproach to the capitalist system.

Atget's own business operated on principles similar to those of the shoemaker. Just before Atget had turned to photography the invention of the dry plate revolutionized the craft by allowing the photographer to make many more photographs in a day than had been possible in the days of the recalcitrant old wet-plate system; in consequence, professional photographers made photographs that no one had asked for, hoping to find the customer later. Atget was an extremist in this regard, and produced almost all of his work on speculation. According to Berenice Abbott he resisted working on assignment, since customers did not know what to photograph, presumably meaning that they did not know *exactly* what to photograph. They knew that the balcony was a subject, but not that the shoes were part of it.

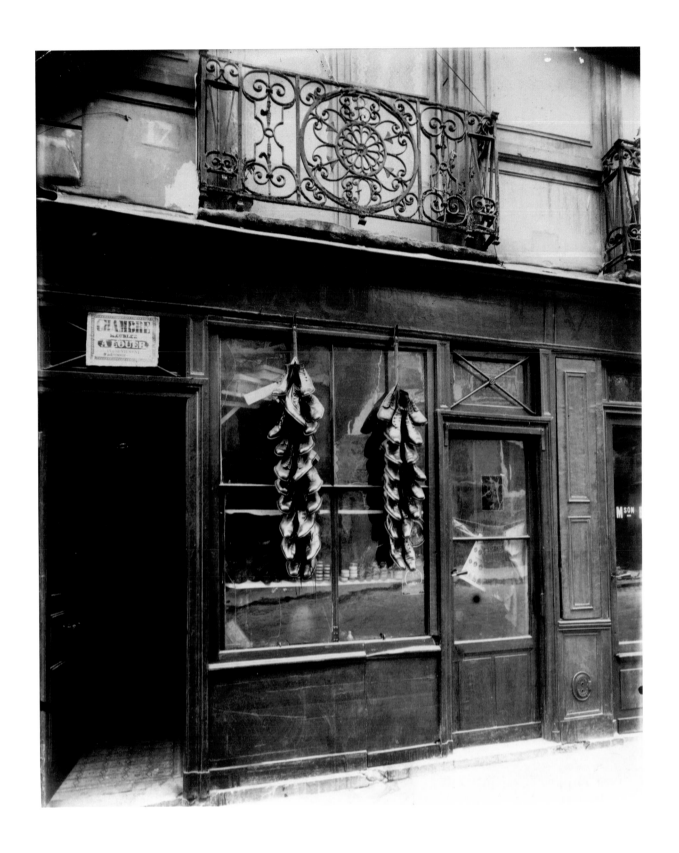

27. *Balcon, 17 rue du Petit-Pont.* (1913)

In 1913 Atget sold an album of sixty pictures of shops and shop signs (*Enseignes et vielles boutiques de Paris*) to the Bibliothèque Nationale. The first forty-seven pictures had been made at a leisurely pace between 1899 and 1910; the last thirteen were all made in 1911, suggesting that Atget had at that point realized that he had in his files most of what he needed to produce an adequately broad representation of the subject, and then proceeded in a systematic and businesslike way to complete it. After 1913 the subject was almost a closed case, but not entirely; from time to time Atget would discover a new shop that needed photographing, and at least once—here at *A la Biche*—he rephotographed a subject that he had included in his 1913 album.

Atget returned to earlier subjects many times, for a variety of reasons: sometimes it was a matter of light, or season; sometimes the subject had changed with age; sometimes it was probably because he had broken or sold his first plate; and sometimes, surely, it was because he decided he could make a better picture. But for whatever reason he rephotographed a subject, he seems never to have attempted to duplicate the first picture. He always approached the subject as new, for he realized that it *was* always new.

His first plate of *A la Biche* conformed closely to what had become almost a standard procedure for the subject: the facade was seen straight-on and symmetrically, the door tightly cropped, and closed, with reflections from its glass panes often providing an ornamental central panel to play against the sign above. (Sixteen of the pictures in Atget's album had been made in 1901 or 1902; in half of these the glass of the door bears some vestigial image of Atget or his camera. Obviously, Atget could not have been unaware of this. For whatever reason, his reflection appears much less often after 1902.)

In his later version of *A la Biche* the formula is changed, not radically but decisively: the facade is now asymmetric, the vantage point is oblique, and from a slightly greater distance. The waiter's jacket (?) on the table creates an outside, and the open door creates an inside. Plates 25 and 26 give us their data in terms of beautiful flat patterns, as taut as an aerialist's net. *A la Biche* gives us a space to enter.

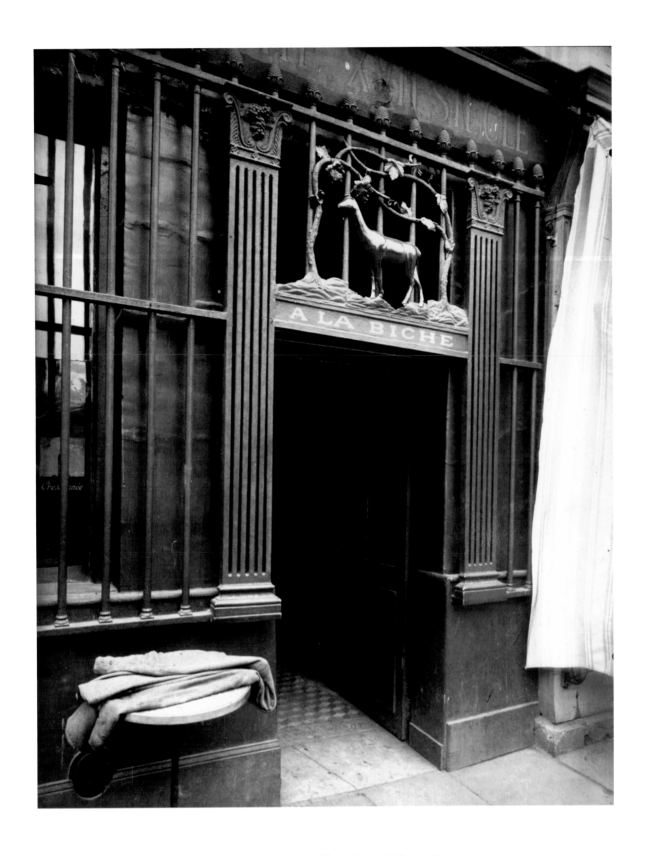

28. *A la Biche, rue Geoffroy-Saint-Hilaire, juin 1922*

Atget's framing—the result of his decision concerning what to include and what to exclude—seems always natural and easy, even inevitable. As Edward Weston put it, Atget never seems to strain for an effect. But perhaps we are fooled by the confidence of Atget's manner, by the casual tone in which he casts his radical thoughts. On reconsideration, we might decide that Atget's framing is often distinctly eccentric.

This image is a case in point. If Atget's subject was the sculptured tympanum above the doors, why did he point his camera at the almost opaque blackness behind the glass. If his subject was the doorway, why did he exclude the doors' lower panels?

In spite of its highly androgynous character, the nude figure has been identified as Dionysus, copied from the Capitoline Antinous.

Guillaume Dubois was finally awarded his red hat by Pope Innocent XIII in 1721; it was said to have cost the French treasury eight million francs. Saint-Simon wrote of him: "All the vices—perfidy, avarice, debauchery, ambition, flattery—fought within him for mastery. . . . The odor of falsehood . . . escaped through every pore of his body."

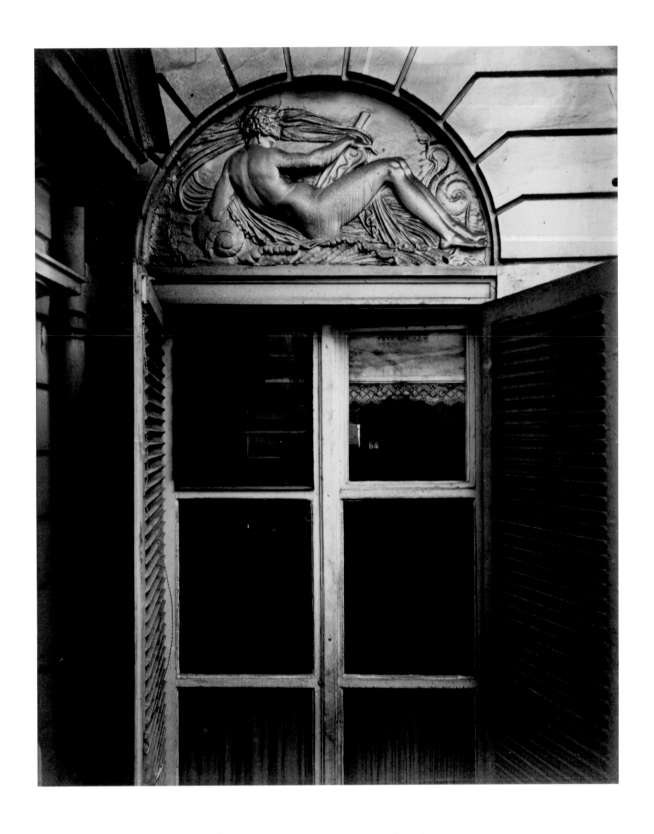

29. *Hôtel du Cardinal Dubois, rue de Valois.* (1913)

Probably late in 1909 Atget made several pictures of his apartment and workroom. It seems to me likely that when he looked at these pictures he found them surprising: most of us have had the experience of finding that photographs of places we thought we knew intimately well are somehow clearer and more strange than the sight of the place itself. Perhaps from this experience came the idea of producing a book, or album, of such pictures, made in the living quarters of Parisians of different social and economic strata.

One might well ask how this more-or-less unknown commercial photographer expected to gain entrance to these interiors. Part of the answer might be that perhaps Atget *was* quite well known in his quarter, in the way that maître d's and undertakers and good butchers and parish priests were well known. As a man of the theater, perhaps he did know Cécile Sorel, the celebrated actress of the Comédie Française, whose apartment was perhaps the fanciest of those he photographed. If he did not know her, his great friend the actor and theatrical director André Calmettes probably did, or was at least a friend of a friend.

Atget completed the project with great speed, and by July 1910 he sold the first copy of his album of sixty prints to the Bibliothèque Historique. He called it *Intérieurs Parisiens; Début du XXe siècle; Artistique, pittoresque et bourgeois*. Perhaps for the first time in his life as a photographer, the album might have been more important in Atget's mind than its parts. Presumably, because he was thinking specifically in terms of the album, Atget made all sixty of the pictures as verticals—an odd decision for a book of interiors, and one that he did not repeat.

None of the above begins to explain why the *Intérieur de M' F., négociant* [wholesaler]*, rue Montaigne* is perhaps the best picture of an empty bed made to date, or certainly the strangest, possibly because of the extraordinary character of the light, which seems to come from the flash of a news photographer, who crawled into the dark room, then rose to his knees, and fired, thinking that the bed was not empty.

Or possibly the bed is in a room on the attic floor, where the light comes in from little eyebrow windows, not from above, but horizontally; or perhaps the bed is in a very large room far from the window, which would cause the same lighting effect: the brilliant, luminous, promising pillows, and the shadowed plane of the bed, with its two dark troughs, in which all the world has slept badly.

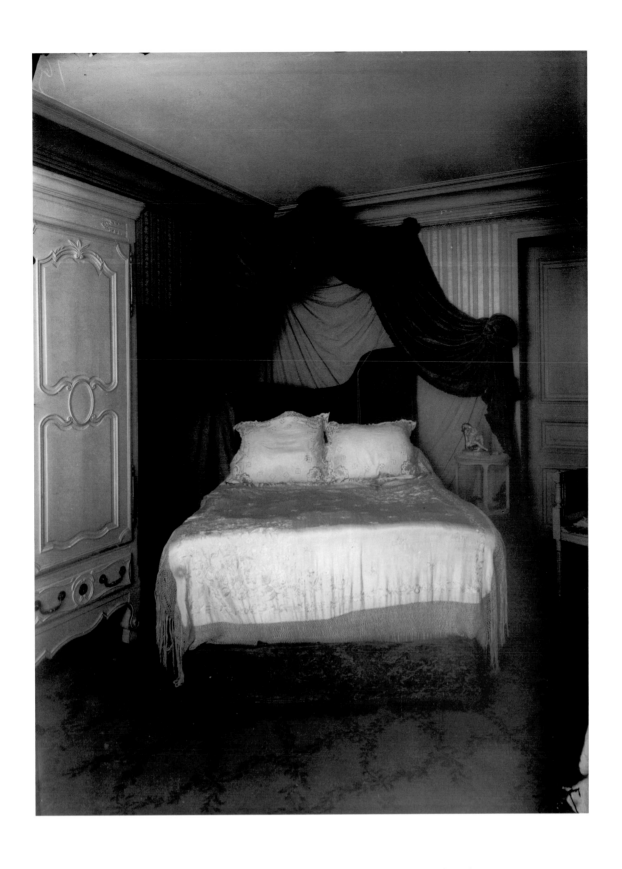

30. *Intérieur de Mr F., négociant, rue Montaigne.* (1910)

The idea of producing a collection of pictures that today might be called a scientifically selected random sample of contemporary interiors was a very ambitious project for a commercial photographer with no staff, no academic connections, and no foundation funding. Nevertheless, Atget doubtless did have a fairly wide circle of acquaintances; and more important, he was an imaginative man, and one whose background in the theater had taught him the difference between role-playing and ordinary lying.

Thus he was able to include in his essay on Parisian interiors photographs of his own apartment, captioned as that of a M^r R., dramatic artist, living on the rue Vavin. It is a nice mixture of truth and invention. Atget had been a dramatic artist, and on occasion still was; until 1913 he lectured from time to time at the popular universities, sometimes with readings from Molière, Victor Hugo, or other favorite dramatists. But he was not M^r R., and he did not live on the rue Vavin, although it was only a short walk—a few blocks away on the other side of the boulevard Montparnasse—from his own place.

Atget lived at 17 bis, rue Campagne-Première with his companion Valentine Delafosse Compagnon, whom he had met while they were both actors. Her career in the theater had been more successful than his and lasted longer, but by the early years of the new century, or earlier, the two lived together in Montparnasse, the neighborhood then favored by struggling artists and other free lances, replacing Montmartre, which had already become a place for prowling tourists.

This apartment was Atget's fifth place in Paris, since he first braved the city twenty years earlier—and it would be his last. When he photographed his rooms he had been there for a decade, and the pictures seem to reflect a stable and purposeful life, and one not devoid of material and intellectual comfort. It is the place of a person of wide-ranging curiosity and an insatiable reader. (Valentine told a friend that he did not dip into Hugo, but read *all* of Hugo.)

Berenice Abbott first saw Atget's work in 1925, and during the next two years she visited Atget more than once (we do not know how often). During her visits she was never invited beyond Atget's workroom—a place of uncompromising utility and spartan simplicity. This is what we would have expected. Although her admiration for the old man and his work was surely apparent, it would have been quite out of the question for her to have been invited into the living quarters: she was young, foreign, and a woman. Tradition, propriety, sound business practice, and the preservation of time all agreed that she could have no place in his private, French living space. In addition, it is conceivable that as an Atget fan she might have seen some of the pictures of the apartment of the dramatic artist who lived on the rue Vavin.

A half-century later, Maria Hambourg led Abbott through the chain of evidence that proved that the pictures were of Atget's apartment. When she had finished, Abbott said: "Oh good. I'm glad the old fellow wasn't as poor as I thought."

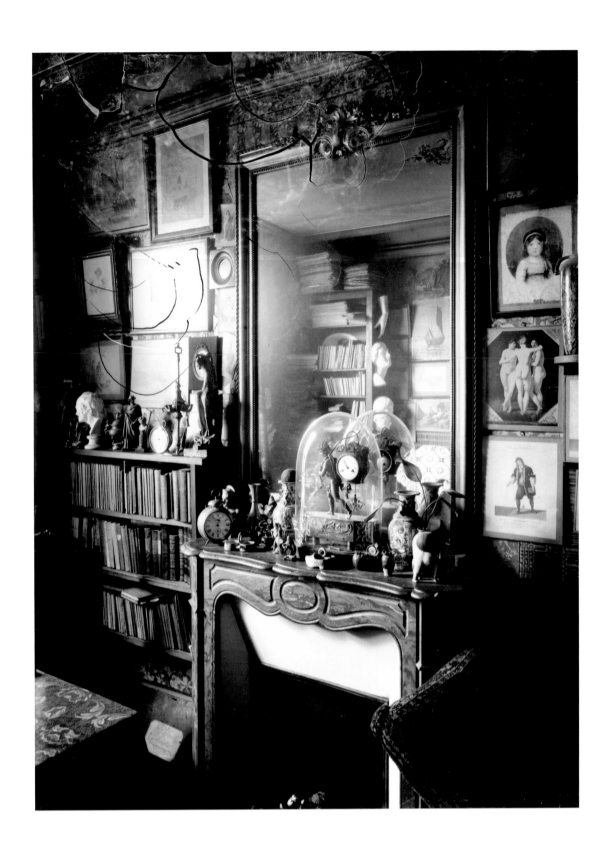

31. *Petit intérieur d'un artiste dramatique, Mr R., rue Vavin.* (1909 or 1910)

It does not appear that Atget actually invented out of whole cloth any of the subjects of his Parisian Interiors series, but in one or two cases, when his coverage of the apartments seemed a little thin, he would flesh it out a little by including a picture or two made in his own flat. Maria Hambourg demonstrated that another picture from the album, also captioned by Atget as "Intérieur ouvrier, rue de Romainville," is actually Atget's own bedroom, and the Atget scholar Molly Nesbit believes that two other plates, supposedly from the apartment of "Mr F., négociant, rue Montaigne La Cuisine," were also made in Atget's place.

In one instance, Atget found it acceptable to identify one tenant as two, making two subjects out of one: thus the apartment of "Mr C., décorateur," is on close examination the same place as that lived in by "Mr B., collectionneur." Or—possibly—the decorator and the collector were friends who shared the apartment.

In this picture Atget claims to give us an interior in the flat of a *worker* who lived on the rue de Romainville, a street on the northeast edge of the city on the border of Belleville/Ménilmontant. We have no reason (little reason) to doubt this. When Atget was ten, it was said that no policeman would venture alone into Belleville/Ménilmontant, but conditions had perhaps improved in some forty-odd years.

It appears that Atget was trying to make the most of the social scale that was accessible to him. He did not in this series attempt either end of the scale: he did not venture into the interiors of the ragpickers or into the wagons of the gypsies, nor did he gain access to the rooms of the true *haute bourgeoisie*. It is likely that he never tried.

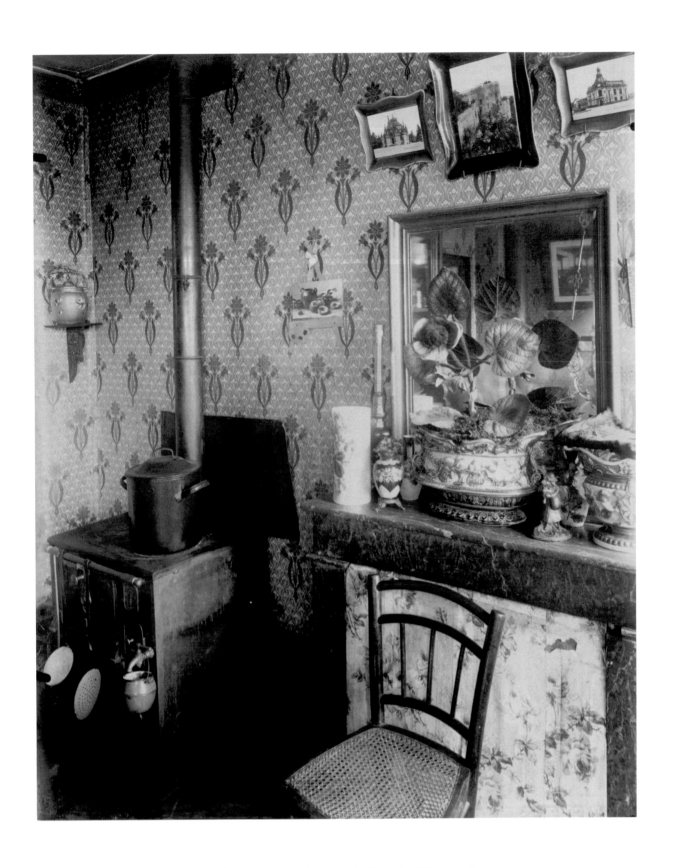

32. *Intérieur ouvrier, rue de Romainville.* (1910)

I t is interesting that Atget spelled the name of this court "Rouen," rather than the normal Rohan. One cannot be sure whether he was being careless or extremely punctilious; the place had actually been, from the fourteenth to the sixteenth centuries, the palace of the bishops of Rouen, but the corruption of the name had taken place long ago, and by the twentieth century it was, in the writer Kate Simon's formulation, "an error too old to erase." On the other hand, using a form that only the initiated would recognize as (in a sense) correct might have flattered Atget's antiquarian clients.

I cannot say why the bishops of Rouen lived in Paris, but note that during much of the period in question Rouen was under the control of the English, and this might have been considered an adequate reason for the shepherd to abandon his flock.

Atget made many photographs here. Maria Hambourg discovered that he had two friends in this court—the illustrator Victor Dargaud and the engraver Charles Jouas—important members of the old-boy network through which he found new customers.

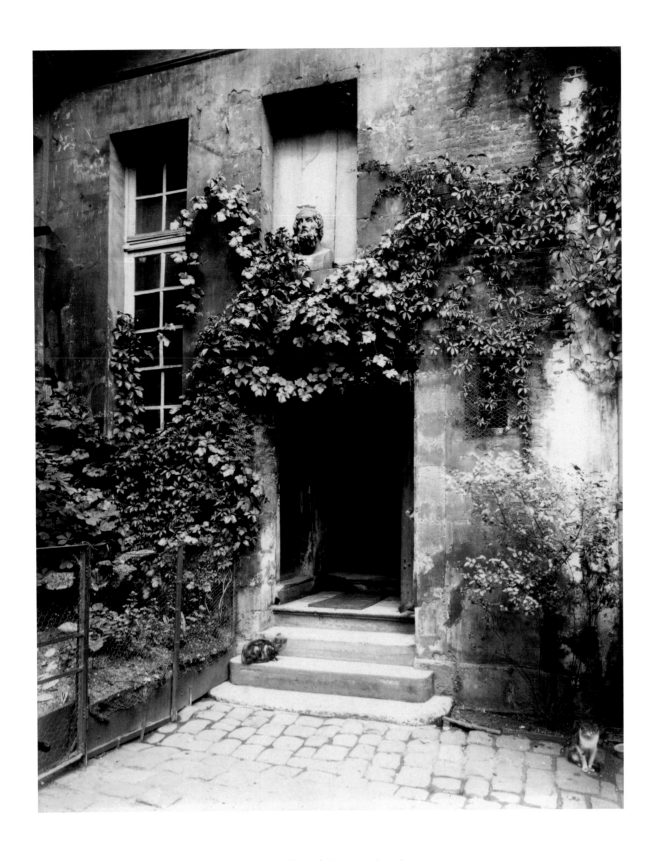

33. *Cour de Rouen.* (1915)

As a matter of convenience we might say that the Pont-Neuf was completed, after many years of hard and expensive work, during the reign of Henry IV of Navarre—perhaps about 1600, a few years before Rembrandt was born, and about the time that Shakespeare wrote *Hamlet*.

But in fact the bridge will be finished only when all of its stones are reduced to sand. For the past four centuries it has been, like humbler structures, in a continuous process of reconstruction, sometimes dealing with merely cosmetic matters and sometimes with the very footings; by now it would not be easy to say whether or not there is still a stone in place that was there when Henry of Navarre was assassinated.

The long stake covered with markings that resemble an electronic bar code is obviously a device to measure the height of the Seine, and it is clear by its vertical extension that the authorities expect the river to flood the quai—if not this spring, then in some future spring.

It is not clear whether the man on the abutment is a philosopher with a fishing rod or a technician with a measuring device, estimating the speed at which the water is dissolving the stone.

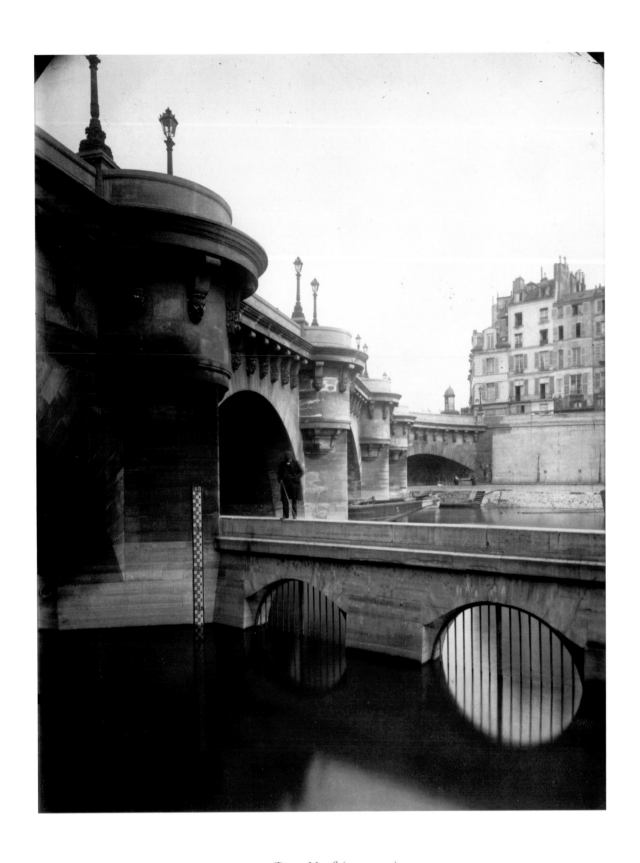

34. *Pont-Neuf.* (1902–03)

The Pont-Marie was almost three centuries old when Atget first photographed it, making it almost as old as the Pont-Neuf. Atget photographed both bridges many times; the picture here, made in his penultimate year, would seem to have been his last try at the Pont-Marie, possibly suggesting that he felt he had finally gotten it right—with the brilliant white sun-shape eclipsing the great black moon.

The function of the prow-shaped abutment is not only to serve as a buttress to the dead downward weight of the masonry but also to protect the foot of the arch by deflecting floating debris away from it and into the open archway. The one seen here would be useful only at high flood stage, when the water was over the quai. The fact that the sycamores are alive and healthy suggests that they were not submerged for long during the great flood of 1910.

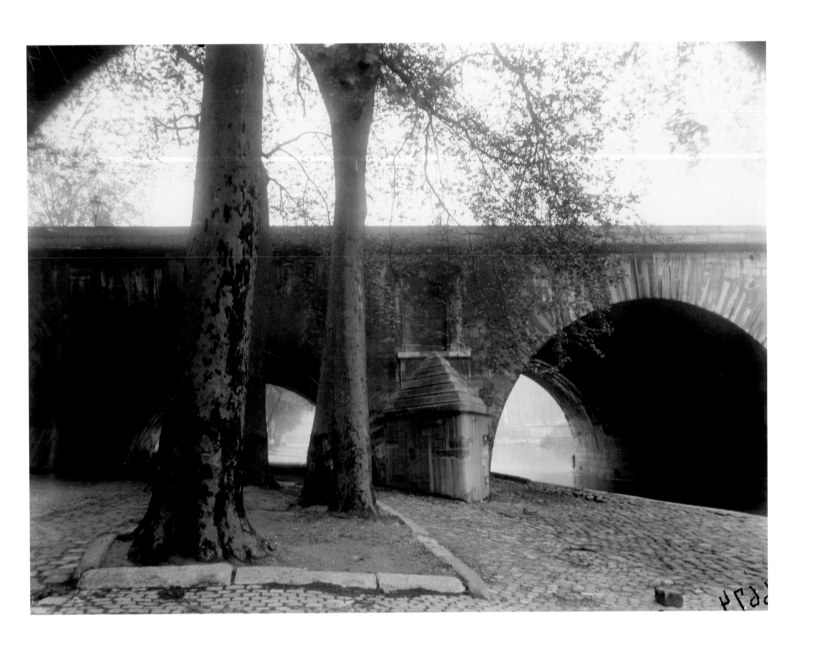

35. *Pont-Marie, avril 1926*

This part of the Pont-Neuf is not really a bridge at all, but a road across the downstream tip of the Île de la Cité, the oldest part of Paris, which (it has often been said) lies in the river like a moored ship.

Atget had photographed this subject a quarter-century earlier, from a vantage point some ninety degrees to the right of where he stood to make this picture. From the earlier position the silhouettes of the two buildings were elided, and blended into an allover urban fabric. From the new vantage point each is dramatically isolated, an effect heightened by the light mist, which draws a translucent curtain between foreground and distance. Now they look like two great sentry boxes on the edge of the frontier, or like the cabins of great ships, looking down the river toward the sea.

Most great historic cities are located on important rivers; Paris was unusual in that it started on a small island in the middle of its river, and when it spread, its two banks grew up different but equal: horse and wine markets on the left bank, grain and cattle markets on the right. When the two buildings in this photograph were new the main thoroughfares of Paris ran north and south, and thus over the bridges of the Île de la Cité, causing such fearful traffic jams that it was considered an offense against the social contract to talk on the bridges.

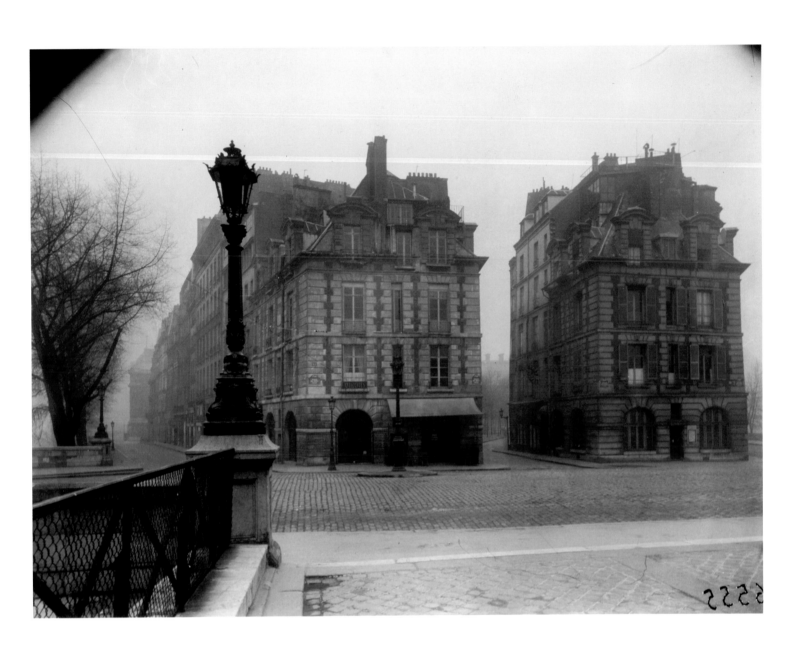

36. *Terre-plein du Pont-Neuf, matinée d'hiver, 1925*

Jean-Baptiste-Camille Corot was perhaps the most beloved of the great French painters—perhaps as much for the sweetness of his spirit (among so many egotists) as for the ravishing lucidity of his best pictures. He spent much of the last half of his life in Ville d'Avray. By the time of the Franco-Prussian War of 1870, he was rich enough to offer the government a special, self-imposed tax for the purpose of buying cannon, powder, and shot to drive the hated Prussians out of the forest of Ville d'Avray. He did not, at that point, quite understand the seriousness of the situation.

After Corot, Renoir and Monet and others worked at Ville d'Avray, and by Atget's time the place itself had a resonance borrowed from the great acts done there—not in the remote past, but only yesterday. Corot had been dead for a generation when Atget made this picture on his first visit to the pond, but Monet and Renoir would continue to work for many years.

Atget himself was an amateur painter, whose tiny oil sketches are neither quite competent nor uninteresting. André Calmettes told Berenice Abbott that he and Atget were greatly interested in painting, knew many painters, and that after Atget left the theater (or was left by it) he had given some tentative thought to becoming a painter. As a photographer, he must have been aware that he was sometimes—especially when photographing in the city's environs—working on the heels of painters, but I recall no other case in which his caption acknowledges the precedence of another artist.

The boat itself represents a modest advance beyond the original of the type: the flat-bottomed, straight-sided tub that has only recently disappeared from the shores of small ponds. It was probably rented by the hour by the proprietor of the inn, who knew that even the most incompetent sailor would have difficulty turning it over, and that in case of trouble the boatsman could scarcely have gotten beyond earshot of the shore.

37. *Étang de Corot, Ville d'Avray.* (1900–10)

Nearly everyone knows that *bagatelle* is a French word, descended from the Italian *bagattella*, meaning a trifle, a mere nothing; but it is also the name of an old English game, vaguely resembling billiards, at which sums were won and lost that could not possibly be thought trifling.

The Bagatelle referred to here is a small chateau on a mere sixty acres in the Bois de Boulogne that could have acquired its name from either of these root meanings. It is indeed a mere trifle in comparison with the great eighteenth-century chateaux, but it is also said to be the result of a wager: in 1779 the comte d'Artois (much later, rather briefly, Charles X) bet Marie Antoinette that he could build the chateau in a month, and evidently won his bet. He was less successful as king; he said that he would rather chop wood than be a constitutional monarch like the king of England, and he seemed to do everything he could to precipitate the revolution of 1830. He then abdicated, which has been called his best career move.

By Atget's time, Bagatelle was perhaps better remembered as the former home of its last private owners, Lord Hertford and Sir Richard Wallace—thought to be half-brothers—who between them acquired the work now known as the Wallace Collection, in London.

Atget photographed the chateau rather dutifully, and reserved his best efforts for the park's trees and flowers: the water lilies, the climbing roses, and the potted geraniums.

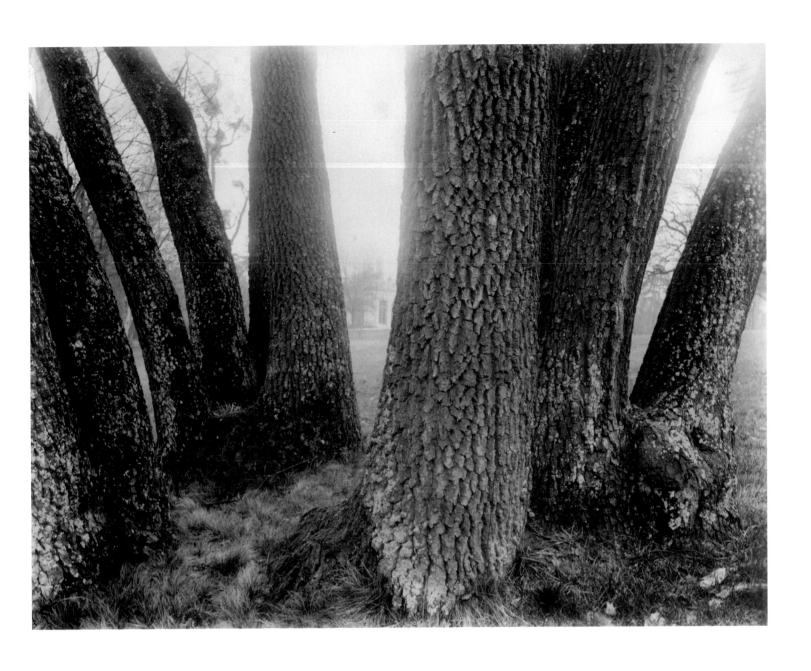

38. *Bagatelle.* (1910 or earlier)

A beginning photographer hopes to learn to use the medium to describe the truth; the intelligent journeyman has learned that there is not enough film to do that. By his early forties Atget had learned that although there may be an inexhaustible number of truths, some are more interesting than others.

He had made many photographs of water lilies, perhaps most of them at Bagatelle, but the two that follow (with adjacent negative numbers) are perhaps the most instructive. The maple leaf in the lower right corner of plate 39 is the same one that appears in the lower left corner of plate 40. By moving an eighth of a turn counter-clockwise Atget has turned white water black, and gray lilies white.

When it has been possible to deduce from interior evidence the sequence in which Atget made two or more variant negatives of a single subject (most often from the direction in which the shadows move) it seems that he consistently numbered his negatives in the order in which he made them. We must thus assume that he did so here also, and made plate 40—surely the lesser picture—after having already made the greater one. It is a heartening lesson for all photographers that even Atget was not always sure. Edward Weston (at roughly the same age as Atget was when he made these pictures) declared that it was his goal to be able to previsualize, before he released the shutter, what the finished print would look like. It would have been a trivial goal, of course, if he had succeeded every time.

39. *Nymphéa.* (1910 or earlier)

40. *Nymphéa.* (1910 or earlier)

tget had a deep curiosity about trees, and seldom seemed to lack a pretext for adding a new tree to his collection, or for making a new negative of a tree that he had photographed before. Berenice Abbott, from Ohio, was as tough as a buckeye and no romantic, and she guessed that Atget saw the tree as a symbol for himself: sturdy and steadfast. Trees appear especially frequently during the first and last decades of his work: during the eighteen nineties, before he had decided to specialize in the documentation of Old Paris, and after the Great War, when he seems to have redirected his life as a photographer toward simpler and more personal goals.

He made at least seven negatives of this beech in the park of Saint-Cloud, photographing it on three occasions between the years 1919 and 1924—once during the summer and twice during the winter. About four years before he made the picture shown here he made a virtually identical negative—from the same vantage point, and with the light striking the tree from the same angle. The earlier picture is much bolder in contrast—more graphic and less plastic—than the one shown here. Before the seemingly intractable puzzle of Atget's system of numbering his negatives was solved, I had guessed that the two negatives were made within minutes of one another. It is now clear that Atget had decided, after the passage of years, that the tonal rendering of his first version was too brittle—insufficiently sculptural—and that it had to be made again, with more exposure.

Early in his life as a photographer Atget often showed the whole tree, its characteristic silhouette pinned against the sky, as in a child's drawing. After the war his trees are not so generalized; their subject is more specific, more sharply focused, and less reassuring. They describe the particular ways that trees articulate their forms, effloresce, bear fruit, grip the earth, claim space and light, and fail.

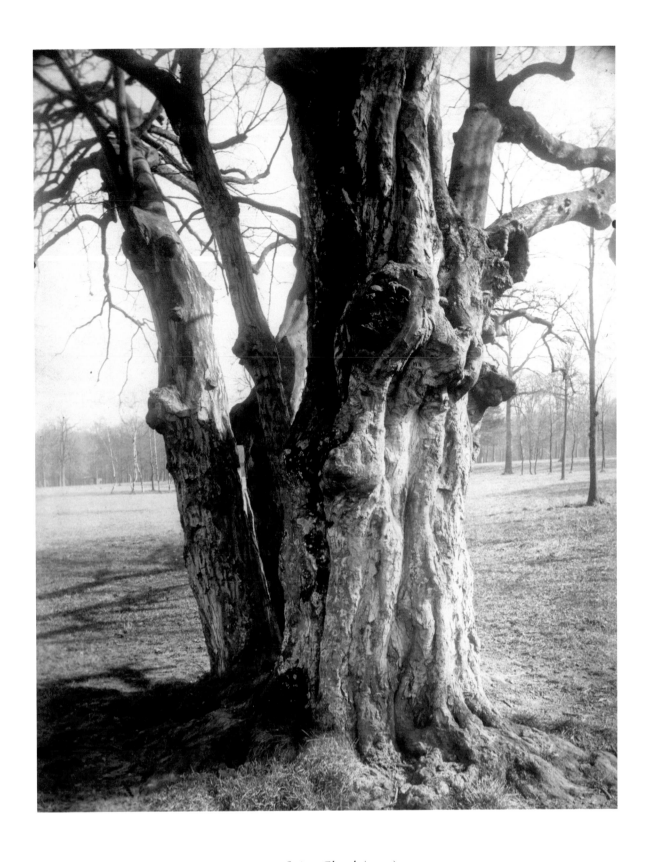

41. *Saint-Cloud.* (1924)

*S*aule means willow, but the willow is a genus of great complexity, and there is no agreement in sight as to the number of species, subspecies, and varieties encompassed under that tent. Fortunately, we are concerned here less with the botanical than with the commercial meaning of the term and not with the whole willow but with *osier*—its pliable twig.

In the mid-nineteenth century, *osier* was exported from France and sold in New York to wholesalers at prices ranging from 3½ to 8 cents per pound, perhaps depending on quality and condition. (The best *osier* was the most limber. Pliny called it *Salix viminalis*—willow to bind with.)

The chief use of *osier* was for basket making, and later for wicker furniture, but some varieties were cultivated to serve as organic twist ties, to bind together bunches of vegetables for the market. Now, even in France, use of the market basket has declined precipitously, and soon these startling, startled trees will have disappeared from the landscape.

Atget's willow looks ancient enough, probably not from years, but from the overly zealous harvesting of its annual crop of shoots. It appears now to have been abandoned to its fulminating, vituperative old age—a tree out of Goya or Redon.

42. *Saules.* (1919–21)

It was not unusual for Atget to photograph the same subject more than once. As he grew older he seems to have been more and more inclined to revisit subjects that he had photographed earlier, as though he was in no hurry at all and wanted to get it right. Or he might have rejected that formulation and said that a given tree, or even a given house, is never the same subject twice.

But even with Atget we do not often get the same humble subject—an anonymous suburban house—revisited a quarter-century later. There is no hard evidence to suggest why he made either picture, but it seems likely that he might have hoped to sell prints of the first one to a painter client. (Dunoyer de Segonzac would have been only seventeen, but Utrillo or Derain and many others would have been old enough.) The second picture was made at the end of Atget's life, when he had acquired a little nest egg, and seemed finally not greatly concerned about selling prints. He did however continue to photograph, perhaps because that was his habit, or one might say his role; making photographs had been for more than a third of a century his way of meeting and understanding the world.

The house is old and substantial. We see here only one wing of the (presumed) U-shaped plan; at the extreme right edge of the 1901 picture we see an entrance—almost surely a subsidiary one—that would lead us into the courtyard and the house's formal facades. The street number is visible, but not quite legible: perhaps it is 12, or 13.

The fortunes of the owner are perhaps past their apogee. The vines have passed from exuberance into intemperance; the roof wants demossing; and one cannot help but wonder how long the giant fender has been allowed to lie on the sidewalk, since it was knocked from its anchor by some drunken teamster.

Twenty-five years later things have not improved, except for the light, which was bold and beautiful on the afternoon when Atget first saw this place, and heartbreaking on the morning when he photographed it again.

On his second visit, Atget moved his camera to the left, perhaps to keep the early morning sun from shining directly into his lens. He has also moved forward, and is in fact now in the middle of the street, but perhaps not quite in the path of the streetcar.

Much of the pleasure of a photograph is in its details. Here we can see that a modest sidewalk has been added in front of the carriage entrance of the house on the left. The fabric of a city, or a house, is not built once, but perpetually.

43. *Châtenay, un coin.* 1901

44. *Châtenay, vielle maison.* (1925–27)

Good pictures are not explained by words, and in the case of the best pictures a writer would be well-advised to save his paper.

Good history can suggest the general circumstances under which a picture was made; it can attempt to describe the shared body of knowledge that defined, at a given time and place, the content of a craft's tradition. It can even attempt to evoke a sense of the intuition of a time, concerning what direction might now be fruitful.

Good criticism can help find a common meeting ground for the work of art and its proper audience, and sometimes even a meeting ground for audience and artist. With exceptional good luck, criticism might with words construct meanings that are different from but consonant with the meanings of pictures. Such constructs of words might possibly guide us toward the neighborhoods where pictorial meanings live.

I have no idea where this picture gets its hallucinatory, threatening power. Perhaps it has something to do with the apparent counterclockwise cant of the picture, although the verticals are erect; perhaps it is the brilliant sky, shaped like a sheet of half-burned note paper; or perhaps it is the low vantage point, that suggests that we are crawling toward the stairway on our hands and knees, pulling behind us an intolerable burden.

45. *Versailles, escalier de l'Orangerie, 103 degrés, 20 mètres de largeur, juillet 1901*

A tget was in his early forties when he made this picture, and it is clear that he was having a wonderful time. He was learning to make what was for him a new kind of picture, full of panache, witty high spirits, and athletic confidence.

It was of course easier to make simple pictures at Versailles than in the outside world, for there the cultivated landscape had already been made a work of art, and largely purged of all those unnecessary, lumpen details that seem to the camera always and stubbornly in the wrong place. Nevertheless, this picture would have been simpler still, and less amusing, if Atget had turned his camera-back vertical and given us simply the sculpture (*L'Air* and her passenger the eagle) neatly isolated against the black foliage. That is what Atget's several competitors would probably have done, and there is no reason to think that the artisans, archivists, and *amateurs* who bought his pictures would have felt ill-served.

Atget did something audaciously different; he gave equal billing to the bench. Once it has been given a prominent place in the cast it is irresistibly tempting to assign it also a place in the plot: were there star-crossed lovers who slipped away at Atget's approach, or royalists plotting a coup d'état, or perhaps a poet writing of the primacy of Air, and of how she scans the horizon in search of Fire, Earth, and Water.

Including the bench also allowed Atget to include the background shape of the negative-positive interlocking commas, the Yin-Yang, or Soo Line Railroad symbol.

46. *Versailles, parc.* (1901)

The accepted technique for photographing sculpture (such as this vase) prescribes that one stand as far from the object as practical, in order to preserve what Heinrich Wölfflin called its characteristic profile. The prescription makes good sense. A flea is too close to know the shape of its dog, and people—except space travelers—have never seen the shape of the earth.

It was, however, Atget's tendency to work from close-up, as shown in an extreme case in the picture of the lamp-shade seller (plate 17). In the narrow streets of Old Paris, there was often no option but to work close, and it became natural for Atget to use a much wider cone of vision than traditional pictorial conventions would consider normal.

During the good weather of 1906 he produced a substantial series on the vases of Versailles, working as was his habit from an extremely close viewing distance. This picture is made from a viewing distance so close that his lens seems almost under the lip of the vase. He is working so close that if the vase were a head, nose toward the camera, the ears might not be visible. He is in fact so close that he needed to make four negatives to work his way around the circumference of the vase.

More than a century earlier Giovanni-Battista Piranesi had described the whole circumference of the same vase (or rather, its original, in the Borghese gardens) in a single etching, which described the vase as Mercator's projection describes the earth—by pretending that it was a cylinder that could be unrolled.

The advantage/disadvantage of Atget's approach is that it emphasizes—in fact exaggerates—the independent sculptural quality of the frieze: the figures seem here almost to escape the geometric form in which they had been encased.

47. *Versailles, vase (détail).* (1906)

Italy had fallen in love with the rediscovered world of the classic past partly on the level of ancestor worship. The makers of the Renaissance could think of themselves as the progeny of the makers of ancient Rome. France, in turn, fell in love not with the ancient past but with modern Italy. Francis I brought Leonardo (and all the others) to France to have him teach modern ways and modern style, and two centuries later the park of Versailles was still being filled with statues of pagan gods and their friends, not because they were related to indigenous superstition but because they were Italian.

The statue here is of Pan, the god of the fields, or conceivably Silenus, the satyr, who was sometimes but not always depicted, like Pan, as a goat from the waist down. The figure shown here seems a little old for Pan, who is most often depicted as a fundamentally innocent juvenile delinquent; and yet it seems too young for Silenus, whom we are accustomed to see as a potbellied old wreck, hopelessly corrupt, and irretrievably sunken into the inadequate consolations of flesh and wine. Nevertheless, Silenus is thought by some to be the *son* of Pan. For astrologists, Pan is a facet of Saturn, who symbolizes time, and its insatiable and destructive appetite for all forms of life.

The time here is not late fall but early spring. The writer or reader on the bench has rushed the season, and sits with his overcoat wrapped tightly around him.

Atget is forty-nine. He has photographed intensively at Versailles during at least four of the preceding five years, and has enjoyed himself doing it. He added substantially to his Versailles catalogue in this year (1906), and then he seems not to have returned for fifteen years, except once that we know of, to photograph an old pine that grew there. When he next turns his attention to the park itself he will be sixty-four, and a different photographer.

48. Versailles, parc. (1906)

Aforgotten professor of the Beaux-Arts system (or, rather, one whose name I have forgotten) explained to his students that good architecture makes good ruins. This is too narrow a prescription, since it dismisses out of hand both glass architecture and the architecture of tents; nevertheless, within the professor's sphere of reference the rule seems sound enough.

The corner of Versailles described here is not yet a ruin, but it is on its way, and it is difficult to believe that it was as good when new as it is here in Atget's photograph, at the beginning of the twentieth century—with its stones cracking and its horizontals and verticals beginning to bend a little to the iron will of gravity. Perhaps we are more sympathetic to architecture after time has stripped away its pretense to immortality.

The softly brilliant sun strikes the vase and its pedestal like a spotlight, but the far end of the terrace is still shadowed by clouds. Glowering in the background are the forces that will finally reduce to sand the great monument of Louis XIV.

It was perhaps not until the time of the Englishman John Constable, a century after the Sun King's death, that a painter would have attempted to describe so evanescent a trick of the weather. And it would seem that photography did not often try such problems until after the invention of dry plates, toward the end of the nineteenth century. The earlier wet-plate method was slow and deliberate, and based on anticipation; if possible a photographer would have avoided those days when heavy clouds scuttle across the sky, continually revising the scene before the camera.

It is surprising to remember that when Versailles was new photography had not been invented, and it is tempting to wonder if André Le Nôtre, the designer of the gardens of Versailles, knew what they really looked like.

49. *Versailles.* (1905)

The ponds and allées of the great parks, because of their clean geometrical simplicity, provided a splendid foil for the freer organic shapes of living plants and representational sculpture. Atget—like Le Nôtre—enjoyed juxtaposing the adventurous open forms against the closed reassuring ones. In this picture the symmetry of the architecture is compounded by the symmetry of the planting, and again by the reflection in the pool. Thus we get the Pavillon Français at Versailles as a Rorschach test, plumbing our responses to twilight, to the kinship of trees and witches, and to the authority of classical order.

In fact, the picture would be less interesting if it were truly symmetrical, like an image in a kaleidoscope. Obviously, the picture is not symmetrical from left to right, since even French gardeners cannot make two identical trees; and in fact the trees have been allowed an increased measure of freedom here, in comparison to the discipline in which they were held two decades earlier, when Atget had made a first version of the picture. More interestingly, the picture is not symmetrical from top to bottom, because the top half and the bottom half are seen from different points of view. The upper pavilion is seen directly on line with the camera's lens, but the lower one is seen from the surface of the water. The image is bounced from the water to the camera. One can see in the picture that the inverted pavilion is seen from a much lower vantage point, which is why its roof line is drawn in so gull-winged a configuration.

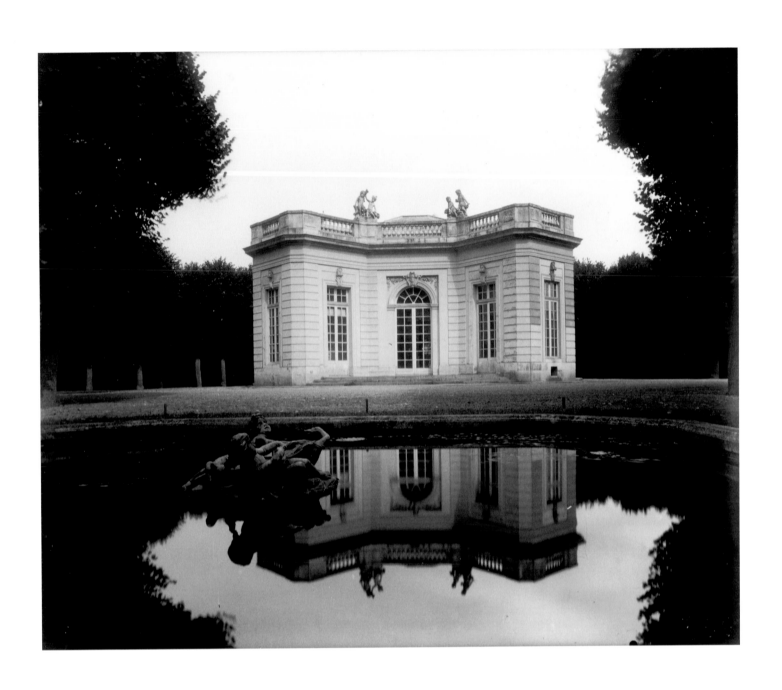

50. *Trianon* [Pavillon Français]. (1923–24)

It is said that in 1921 Atget was commissioned by the painter André Dignimont to photograph prostitutes and brothels. If this is the case, Atget seems to have pursued the commission with an uncharacteristic lack of energy. According to its negative number, this picture was the first plate in the group; during the next ten months he added perhaps a dozen more to the set, most of which may have been made when he happened to be in the appropriate (or inappropriate) neighborhood.

La Villette was the quarter in which Atget first lived when he came to Paris in (we think) 1878. His first semipermanent bed in Paris was at 97, rue de Flandre, on the wrong side of the Bassin de la Villette and its system of commercial shipping canals, and just to the west of the great slaughterhouses.

I can propose no plausible explanation for Atget's caption, since the rue Asselin appears (on my maps) to be on the other side of the river, in the fourteenth arrondissement, in fact not a long walk—just the other side of the Montparnasse cemetery—from Atget's own apartment. Obviously, the caption is not designed to deceive a Parisian; it represents merely a slip of Atget's hand or a later mistake in transcription. Or perhaps the street name was later transferred to another quarter to protect the innocent.

During the Second Empire of Napoleon III and the Third Republic that followed it, more than street names changed. The new commercial prosperity that came to France, and especially to Paris, under and after Napoleon III had an interesting effect on the distribution of the poor, the merchant classes, and the (former) aristocracy. Earlier, the segregation between classes tended to be organized vertically: the poor lived in consumptive basements and unheated attics but generally in the same neighborhoods as their betters, which encouraged a superficial comity. With the new prosperity of the Second Empire, with the clean new central city that Baron Haussmann was creating, and with modern trains, the poor could be segregated horizontally, where they would at least sleep and breed out of sight. In 1860 the boundaries of the city were extended to the fortifications, and the number of arrondissements was increased to twenty, which with a certain amount of gerrymandering brought the new worker suburbs into the political city.

At the time of the Paris exposition of 1867, Mark Twain visited Paris and loved it, but claimed that one could hire a murderer there for seven dollars. He was of course famous for hyperbole, and in any case things might have improved by the time the young Atget came to live in la Villette eleven years later.

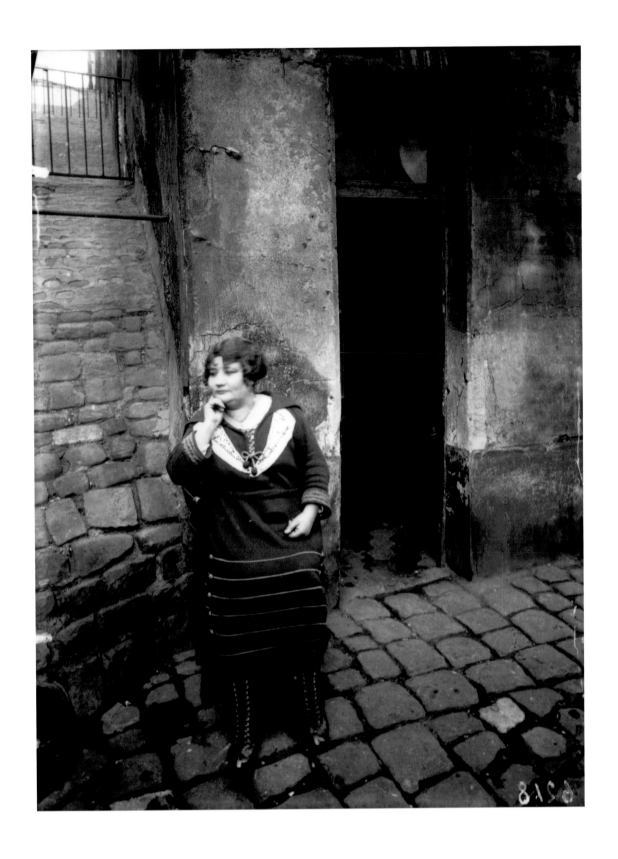

51. *La Villette, rue Asselin, fille publique faisant le quart devant sa porte, 19ᵉ, 7 mars 1921*

The American photographer Garry Winogrand said that he had no philosophical objection to photographs that had been set up; it was simply that he did not consider himself imaginative enough to invent a world as fascinating (and often, as bizarre) as the one that confronted him on the street every day.

If one visited every central casting agency on earth to find the perfect models for a picture of three madams (or a madam and two workers) weighing business prospects, one would never find these three. Even if one specified that they should be chosen to represent generosity, stupidity, and greed, respectively, one would never find these perfect exemplars. If they had been dressed by the great Edith Head (three straps over the fat instep, each held by a false pearl) they would not be dressed as perfectly as they are here, and Fred Zinnemann would not have framed them so well in a doorway as they have framed themselves.

Another American photographer, Paul Caponigro, once said: "Of all my photographs, the ones that have most meaning for me are those that I was moved to make from a certain vantage point, at a certain moment and no other, and for which I did not draw on my abilities to fabricate a picture, composition-wise or other-wise. You might say that I was taken in."

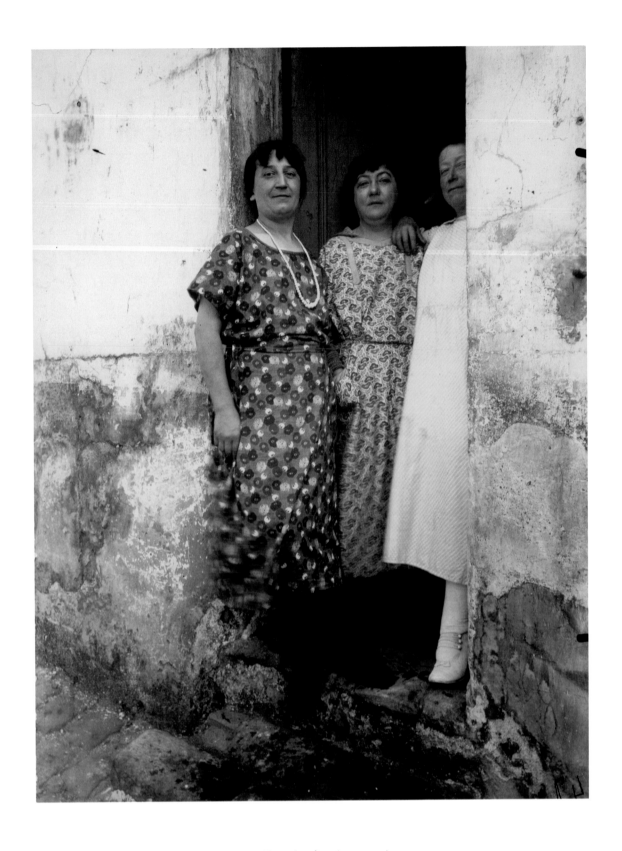

52. *Rue Asselin.* (1924–25)

The single most important contribution to Atget scholarship is surely that made by Maria Hambourg, when she established, in the early nineteen eighties, that Atget had divided his work into thirteen categories, or series, some small and some large, and when she identified the numerical sequences by which these categories were identified in Atget's file. From those data she was able to produce a chart that enabled the rest of us, for the first time, to date Atget's pictures with reasonable certainty.

At the same time, she estimated Atget's total production—the pictures that he saved—at about 8,500 pictures. That would be, on average, about 250 pictures a year, or, if they were made chiefly between March and October, as Hambourg believes (leaving the remaining four months for printing, housekeeping, and selling), one picture a day, over a span of thirty-five years. They were not, of course, all equal.

The rue Broca is omitted from the maps of many Parisian guidebooks. The fact has probably inconvenienced few tourists, and surprised few of the street's residents. It is not clear why Atget went there, or why he made this photograph. It was surely not for the beauty of the architecture nor in celebration of the life that was lived there. The great modernist architect Le Corbusier chose the photograph, a generation after it was made, as an illustration of the tubercular slum. But Le Corbusier could easily have found a more consumptive-looking photograph of a slum. Surely he picked this one in part because it was good to look at—as sound as a bell.

In the same year—perhaps even the same day—Atget made a photograph of a shoe shop a few doors down the street. He filed that picture in his Picturesque Paris series, perhaps because of its commercial content, and put the picture reproduced here in his Topography of Old Paris series, possibly in the hope of selling it to the Bibliothèque Historique, to which he had already sold hundreds of pictures that he had filed under that label. The Bibliothèque was however not so easy a mark that it would buy everything that Atget marketed under the Topography rubric, and I do not know whether or not they bought this one.

It is of course possible that Atget made the picture for fundamentally the same reasons that we take pleasure in it. He was a man who produced the greatest share of his work in the twentieth century, and who died twenty-one years after Paul Cézanne. The fact that he was a commercial photographer did not, presumably, prevent him from taking pleasure in the apparently random but perfect patterning of the black openings in the wall. Perhaps Le Corbusier's eye was also caught by that, although he would try nothing like it until his chapel at Ronchamp in the fifties.

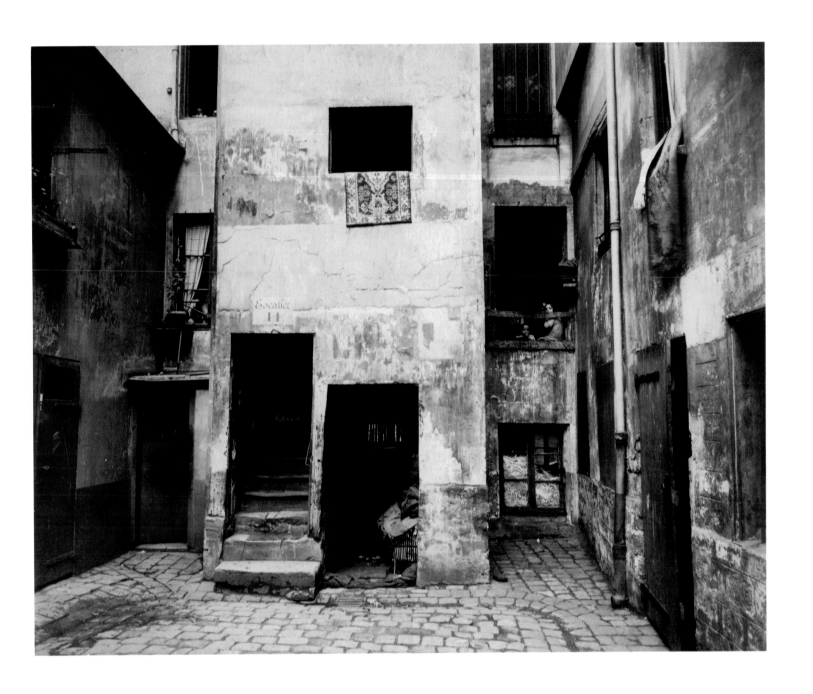

53. Cour, 41 rue Broca. (1912)

In 1910, after finishing his album of sixty *Intérieurs Parisiens* (plates 30, 31, 32) Atget began on another album on the city's *voitures* (wagons, carriages, etc.), and had it finished before the year was out. Although he already had many good pictures of, or including, vehicles of various sorts, the sixty pictures for the album *La Voiture à Paris* were all, or almost all, new. For this set of pictures he got closer, eliminated context and atmosphere, and described just the artifact. From the best of these pictures a good carriage maker could almost build a duplicate, although he would of course prefer drawings.

The *tombereau* resembles the back half of a Conestoga wagon, with which it surely shares a common and ancient ancestry. Nevertheless, this great dinosaur of a vehicle is probably not as old as it looks, since it is—and the word *tombereau* means—a dump cart, designed so that the box can be emptied while the horse or ox was still between the tongues—an important advance in efficiency. Today the term *tombereau* is likely to mean to us the cart in which so many enemies of the Revolution (as defined at the moment) were carried to the guillotine. In this use, its advanced technical capacity was unnecessary, and I believe unused.

In 1910, when Atget did his album on *voitures*, it contained sixty vehicles, of which fifty-nine were drawn by horses, or perhaps once or twice by oxen. The sixtieth was a steam-roller.

54. *Tombereau.* (1910)

As a specialist in Old Paris, Atget sold most of his work to people who thought that older was better, and on occasion he was probably tempted to think so himself. It is remarkable that, although he photographed Paris for thirty years, and found his way into most of the areas that were omitted from the guidebooks, he never intentionally photographed the Arc de Triomphe, the Tour Eiffel, or any of the great monuments of Baron Haussmann's nineteenth-century reconstruction of the city.

Nevertheless, he was not unalterably opposed to the concept of change, and in spring 1922 he made what is perhaps his first photograph of an automobile—a very handsome Renault touring car, parked in a small court on a small, almost nonexistent street that appears more or less at the intersection of rue Mouffetard and rue Monge.

When Atget made his *voitures* album, in 1910, there were more than ten thousand horses employed in pulling Paris streetcars. Three years later there were only sixty horses engaged in the same work. For the really hard work, draft animals maintained their roles for awhile, but it was clear that their days were numbered. Finally Atget faced up to the facts and photographed an internal combustion machine. He chose a very good one, as was his principle and his habit.

In 1900 there were two thousand automobiles operating in Paris. In 1914 there were twenty-five thousand automobiles operating in Paris. I have no data for 1922, but in any case, the beauty shown here might not have been included in the count, since its engine seems to be lying on the floor of the courtyard.

(Across the rue Monge from the tiny rue de Valence lies the Impasse de la Photographie. It is an issue that has been discussed now and then elsewhere, but only the French named a street after it.)

55. Cour, 7 rue de Valence, juin 1922

The Paris of Atget's time was ringed by three distinct lines of fortifications. The innermost of these constituted the boundary of the city proper. To the south, the second of these perimeter defenses was barely a mile from the city limits, and only four miles from the Louvre. The army was especially concerned with the city's vulnerability from the south, since the high ground of the Châtillon plateau afforded a platform from which the new rifle-barreled cannon could hurl shells of great destructive power (by the standards of the day) into the heart of the city.

While the army considered how best to use, for the defense of the city, this mile-wide ribbon between the first and second fortifications, it persuaded the government to prohibit the erection of permanent structures in that area. This naturally made it a haven for squatters; in the *zone* (as it was still called even after World War II) a squatter's claim to the dozen square meters that he occupied could be effectively challenged only by another squatter.

Perhaps most of the residents of the *zone* were gypsies, or Romany, who—perhaps because they appear uninterested in real estate—seem to remain the most invisible and the least discussed of all sinned-against ethnic minorities.

Atget apparently worked with perfect calm and equanimity on the roughest waterfronts, and in the neighborhoods of the slaughterhouses and tanneries of Paris, but he seems often to have been slightly nervous in the *zone*; in any case his framing and focus seem uncertain, especially when he confronts the people who lived there, who stare at him with an incomprehension that seems to echo his own.

This plate is perhaps atypical of the series; it seems to suggest a degree of empathy between the subject and the photographer that probably distorts the positions of both.

56. *Romanichels, groupe.* (1912)

Poor people have been photographed better and more thoroughly than rich people, although, if given their choice, they might well have declined the honor. Perhaps one should say, more precisely, that more good photographs have been made of poor people than of rich people.

Poor people have been better material for photographers than rich people, first because they have understood intuitively that—unlike the rich—they have no right to privacy, and second because many of them live much of their lives on the street, a public place. There may however be a third reason why photographers prefer to photograph poor people, which could be that poor people are richer in texture than the merchant class. Their clothes, their houses, their environments, even their faces have a richness of surface that photography loves.

In earlier times, before the Revolution, the aristocracy—dressed in satin, sable, leather, velvet, steel, and feathers—offered a similar visual luxury for painters, but by the nineteenth century only the higher officers of the army and navy were allowed to dress like exotic birds, and even with them, flamboyant excess had become fairly well standardized.

The idea of the picturesque is dependent largely on texture. The rusticated or rusticating wall, the thatched roof, haystacks, homespun cloth, cobblestone streets, and *back-lighting* are all deeply implicated with the picturesque, and the eradication of such surface luxury was a central tenet of modernism. Two decades after Atget made this picture the moral position of modern architecture insisted that the walls of buildings should be disembodied planes, as pure as empty movie screens.

57. *Villa d'un chiffonnier, boulevard Masséna.* (1910)

After Atget, virtually all photographers photographed empty chairs in gardens. At least one photographer produced an entire book of empty chairs in gardens, and if that was perhaps excessive it nevertheless indicated how compelling the motif was to photographers in the middle of the twentieth century. The empty chair in the garden was a symbol for the person who had waited there, and finally left; or the person who had not yet come, but still might.

Perhaps Brassaï made the definitive empty garden chair photograph, and surely his friend Henry Miller (in *Max and the White Phagocytes*) wrote the definitive caption for all such photographs: "Among all the objects which Brassaï has photographed his chair with the wire legs stands out with a majesty which is singular and disquieting. It is a chair of the lowest denomination, a chair which has been sat on by beggars and by royalty, by little trot-about whores and by queenly opera divas. It is a chair which the municipality rents daily to any and every one who wishes to pay fifty centimes for sitting down in the open air. A chair with little holes in the seat and wire legs which come to a loop at the bottom. The most unostentatious chair, the most inexpensive, the most ridiculous chair, if a chair can be ridiculous, which could be devised. Brassaï chose precisely this insignificant chair and, snapping it where he found it, unearthed what there was in it of dignity and veracity. THIS IS A CHAIR. Nothing more. No sentimentalism about the lovely backsides which once graced it, no romanticism about the lunatics who fabricated it, no statistics about the hours of sweat and anguish that went into the creation of it, no sarcasm about the era which produced it, no odious comparisons with the chairs of other days, no humbug about the dreams of the idlers who monopolize it, no scorn for the nakedness of it, no gratitude either."

Miller is, of course, pulling our leg. The photograph is about all the things that he denies.

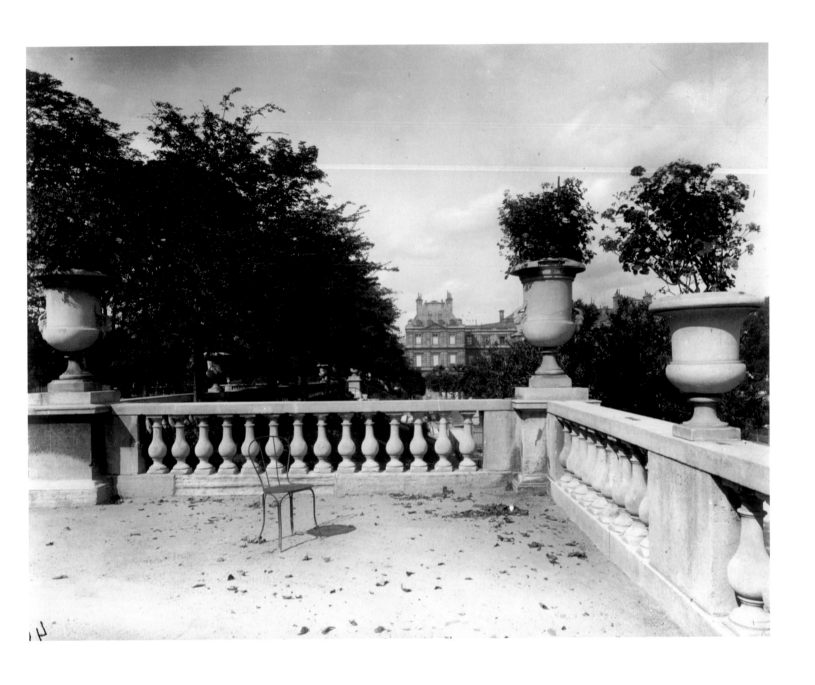

58. *Luxembourg.* (1902–03)

Atget labeled this picture *Luxembourg*, and he cannot be faulted for that; the picture was made in the garden and near the palace that bear that name, and it shows something (though not much) of both. The names of pictures are in any case generally merely labels—more or less useful for identification purposes, but seldom to be regarded as explanations of the pictures' contents. In the case of photography, which by Atget's time had become an unprecedentedly fecund system of picture making, one could no longer think up enough titles to identify all the pictures and was reduced to using numbers. Atget photographed the Luxembourg gardens over a span of at least twenty-five years; I have no idea how many pictures he made there, but the total was surely in the scores, and probably in the hundreds. Most of them were captioned merely *Luxembourg*, plus a negative number, but the content—the meaning—of each picture is different. Some of them have to do with the way that photography can express intelligent appreciation of the work of excellent architects, or sculptors, or gardeners; and some have to do with the way that photography can express passionate appreciation of the world itself.

This picture was among the last—perhaps the last—of the pictures that Atget made in the Luxembourg. It was made the month after the death of his beloved Valentine Campagnon—a more successful actor than he, who had cast her lot with him, and had shared his life for more than thirty years.

It would be inadmissible to say that this picture is about life and death, or gain and loss, but one might possibly say that it is about evanescence.

59. *Luxembourg.* (1923–26)

To review, Atget was a commercial photographer, and although he only rarely worked on assignment, it is fair to assume that he generally had in mind some notion of who might buy the pictures that he was making.

On the other hand, we should not discount the possibility that the makers of works for commerce—the writers of novels, for example, or the producers of movies—might on occasion become carried away by the fascinating possibilities inherent in their problems, and do something better—or at least different—than the thing demanded by strict market requirements. In addition, it is well documented that the makers of novels, movies, paintings, etc. often misjudge what will sell, and in spite of purely venal motives manage to produce works that no one will buy.

It would be very useful to know whether or not Atget really expected to sell this picture, and if so, to whom. Among his regular customers were archives that collected records of the artifacts of old France, and also painters and illustrators who collected photographs as picture parts. Both groups were potential customers for photographs of ancient mills, but it seems unlikely that either group would have chosen this picture. For the archivist, the picture does not spell out clearly enough the technical details of what had been a substantial work of engineering. For the painter, the picture is too good to be tampered with. It is not a picture part; it is a whole.

When Atget made this picture the Great War was almost a year old. During the previous fall, the French had driven back the Germans at the Battle of the Marne, with staggering losses on both sides. After making this picture Atget did almost no work during the remaining three years of the war. Several plausible explanations have been advanced to account for this, but none to place our faith in.

60. *Charenton, vieux moulin.* (May–July) 1915

Crépy-en-Valois was an ancient capital of the Valois, who had ruled France for two and a half centuries, ending with the rule of Henry III. Some say that it was Henry who, while still the duc d'Anjou, was responsible (at the instigation of his mother Catherine de Medici) for the Massacre of Saint Bartholomew in 1572, which began as an attempt to assassinate the Huguenot leadership and which ended with the killing of perhaps 50,000 Protestants and presumed Protestants.

A century and a half earlier, Crépy-en-Valois had suffered under another King Henry, England's Henry V, who after his victory at Agincourt stayed on in France for another five years of war and diplomatic maneuvering before marrying Catherine of Valois, daughter of King Charles VI. One can hope that this union finally improved conditions for the locals, even if only temporarily.

By the time Atget visited Crépy-en-Valois, its days of glory were far behind it. It is not known why he visited this town forty miles from Paris, but it seems unlikely that it was to photograph this house. Atget says that it is from the sixteenth century, and its bones may date from that time, but much of its flesh would seem to be the result of later remodeling. Rather more architecture has been crammed into this corner of the courtyard than there is room for; the false arch over the doorway, especially, has the flavor of one improvement too many.

In addition, the skin of the building in bad repair, and the curtains in the window hang at a crooked, slatternly angle. Nevertheless, the picture is marvelous, and perfectly clear, in the sense that a mystery can be clear, even if unsolved.

61. *Crépy-en-Valois, vieille demeure XVIe siècle.* (August 1921)

erhaps Atget went to Crépy-en-Valois to photograph this street—this unchartered museum, this Delphic demonstration of inscrutable, ineffable aesthetic principle.

The beauty of this street is of an order not mentioned in the catechisms of the town planners. On this street no opening or floor plane or roof line aligns with any other, and no module of proportion can be detected. It is in part the perfect consistency with which the iron rule of *laiser-aller* is obeyed that gives the street its seamless coherence, plus the fact that the street is built from local stone and is thus woven together with material of the same (similar) color and texture. Perhaps the road is also the same stone, forming a continuous fabric, bent upright to form the wall.

The freedom to place small openings anywhere is inherent in masonry construction, which is plastic, like pottery, and thus free of the constraints of a frame. Masonry is interesting also for its habit of preserving its own archeological record. The central building here, especially, is a history of revised priorities. The larger arch above the surviving door was big enough to give entry to a carriage; the smaller one would accommodate a horse. The former arches above the second-floor windows are something of a puzzle. Perhaps the space had been a workshop, open to the roof, and with excellent light; when the attic was made a separate room, its floor occupied the space where the arched window tops had been.

The photographer needed to demonstrate no fancy footwork here, but merely to recognize the proper boundaries of the subject, produce a good negative, and give thanks.

62. *Crépy-en-Valois.* (1921)

This is Atget at the height of his powers. In gross terms, this picture is similar to the pictures that were made by all the excellent postcard and souvenir photographers who were working the same, or a similar, vein during the same years.

Many of those good professionals deserve their own monographs; nevertheless, Atget did at least three things differently than they were likely to have done. First, he moved to the left, so that the six-slice pie of his image becomes eccentric rather than symmetrical, and so that he is closer to the masonry wall; second, he panned his camera leftward toward the wall, emphasizing its cool gravity, and pushing the nominal center of his subject to the right edge of the picture; and third, he exposed his plate very heavily to record every stone, leaf, and blade of grass in the shadowed foreground. He understood that the background could afford to be vague and ethereal, that (in fact) it was better that way.

In Atget's time it was an almost universally honored rule that the camera should point away from the sun. This was a good rule, especially in the days before coated lenses and films with anti-halation backing, and Atget followed it quite faithfully for thirty years. But by the time he reached his sixties he had discovered that the flare created by shooting into the light could melt what was sometimes the too-solid flesh of the world, and suggest the radiance of the sun.

63. *Ballainvilliers, entrée du village, juin 1925*

Except occasionally, as (for example) during revolutions, the French have managed very well to sublimate the periodic human tendency to behave violently toward one's fellow men, and have directed these impulses toward their trees. At regular intervals willows and poplars and plane trees are cut back to little more than stumps, as though their natural efflorescence were a sin against order and rationality.

It is true that the French, to their credit, do not often cut their yews and boxwoods into the shapes of deer, or giant green birds, as the English have been known to do; the French taste runs rather to a more military sort of control—to ranks and files of crisp geometric trees and bushes, as though called to attention for an inspection by the goddess Pomona.

Art in this spirit is not easily accessible to the modern sensibility; especially if it is well done, it seems the botanical equivalent of a John Philip Sousa march, but when done in an amateur, half-competent manner it has the charm of a folk dance on the village green.

Here in Atget's picture, the Gothic arch in the cordoned hedge—of pear, perhaps—is one man's homage to the gardens of Versailles. It required of that man, in labor and attention, more than he could in good conscience devote to it, and it touches us as the expression of a selfless passion. It is made even better by contrast with the merely, and barely, functional gate, cobbled together out of scrap lumber and chicken wire.

64. *Entrée des jardins.* (1921–22)

W e now have pumps so deep-reaching and powerful that we can draw down even the Oglala aquifer, the ocean of fresh water underneath the Great Plains, which once seemed inexhaustible.

People of very recent times were not so blessed, and were forced to rely on simpler technologies, and on frugality. The modern steel-vaned windmill, perfected during Atget's youth, was a great breakthrough in water retrieval, but it did not cause people instantly to abandon the older method of catching the water before it hit the ground, as shown here in a primitive form.

Fresh water falls from the sky. Our roofs keep the water out of our beds, but the roof of a small house can also gather (let us say) one hundred gallons of water from a modest (quarter-inch) shower. The conventional retrieval system of gutters and downspouts is doubtless inefficient; nevertheless, one might hope to save more from the shower than could be held in the forty-gallon barrel under the downspout, so the farmer has arranged an auxiliary water trough that allows him to fill the washtub also.

Water is a life-and-death matter, and hydraulics is a great game, as every child (making dams in the gutter in the springtime) knows.

65. *Verrières, coin pittoresque.* 1922

Before the Great War Atget had done an extended series of photographs of Parisian wells—the places, before the modernization of the city, where the women of the neighborhood would meet to get water and share information. Atget, a man of the modern world, would not have been tempted to think, with Macbeth, that stones could speak. He was not one to think that a residue of those trillions of words of gossip, calumny, accusation, distortion, confession, judicious clarification, true-and-false witness, and simple babbling might have imprinted itself on the stones of the walls and the pavements of these ancient places.

And yet, it is a simple objective fact that wells are richly encrusted with symbolic and associative meanings that have not yet attached themselves to the modern mixing faucet; and for this reason it is acceptable, when photographing a well, to include a wider range of data than a literal-minded person might think relevant.

Wells are the places where pilgrims sought the water of salvation; a well was the place where Jacob met Rachel; wells were the places that the Philistines filled with dirt; in a specifically French context, I think that Jeanne d'Arc met her angel at the well. If not, it was an unfortunate lapse. If so, the place might have looked like this to her.

After the war Atget's work changed, in a way that might be described as a movement toward a more romantic view—or that might better be described as laying claim to a broader spectrum of feeling.

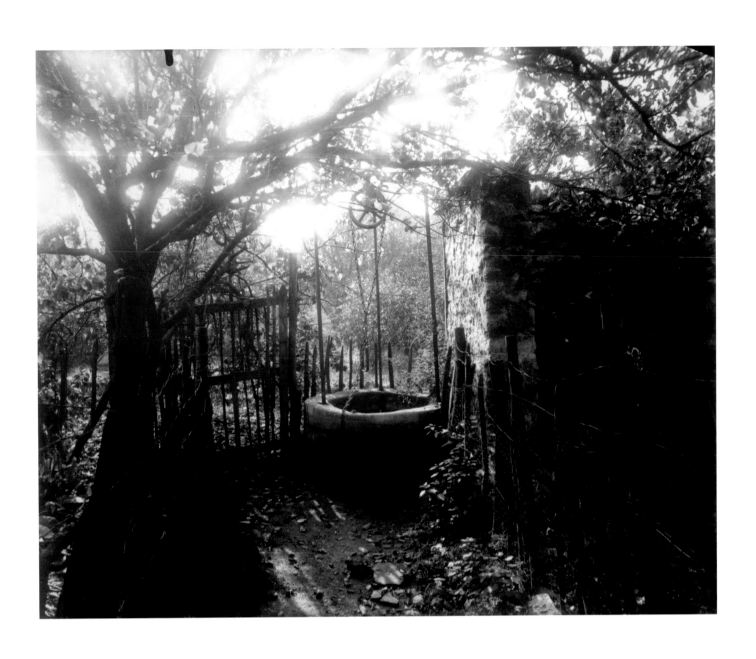

66. *Vieux puits, petit chemin, rue de la Gare, Châtillon.* (October?) 1922

J ust before Atget made this exposure he made one of the entire house, an asymmetrical, unpretentious beauty, its ancient limestone skin showing the erasures of many remodelings, as the size of the family and the pattern of its needs changed.

It is a commonplace that large plate cameras are cumbersome and slow, but this picture and the one that preceded it demonstrate that Atget could work very quickly. In another minute the beautiful raking light would have disappeared from the face of the house, and with it the taffeta sheen of early morning. But the light seems scarcely to have changed between Atget's two exposures.

There was time enough, nevertheless, for the girl to appear in the doorway, and for the cat to have arrived to fill so decoratively the lower right-hand corner.

When I first leafed through the pictures of Atget's wonderful villages—each with a square that boasted its own perfect bakery and its own sweet church, and a world-class wisteria vine, espaliered against a bright stucco wall—I envied the photographer who had traveled the length and breadth of France to discover these marvelous places. Soon afterward I learned that Atget had not traveled as extensively as I had thought; and later I learned that he had made day trips, back and forth from Paris, to these exotic places. The village of Gif, in the valley of the Yvette, was twenty miles from the Gare du Luxemburg, in Paris.

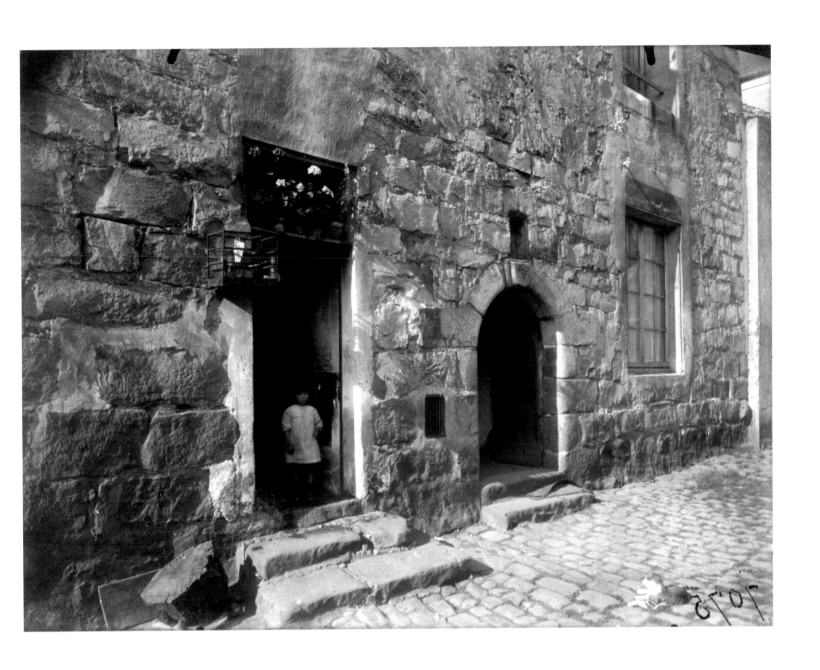

67. *Gif, vieille ferme.* 1924

The evidence suggests that Atget was a free thinker; in any case there is no evidence that he was a practicing Christian, which perhaps suggests that it takes an atheist to photograph a church properly.

Or perhaps it would be more precise to say that faith is no substitute for craft.

Or perhaps even that formulation is too sweeping; Atget was not always especially good at photographing the famous churches of Paris, but no one photographed as well as he the anonymous churches of the villages. It is not easy to know whether such differences should be explained in terms of philosophy or craft, or in terms of some private intuition to which the theologians have not given a name.

As Atget grew older he became technically more adventurous. It has been pointed out that one expression of this growing bravery was his willingness to point his camera into the sun, which would cause detail to be swallowed up—burned out, in a great halo-like penumbra. There was a second aspect to this new knowledge: flare could be used to suggest great brilliance—a more intense brightness than the paper could (from a technical point of view) actually record.

Rembrandt (the etcher) and all competent printmakers after him understood this, but what etchers know cannot easily or automatically be adopted by photographers.

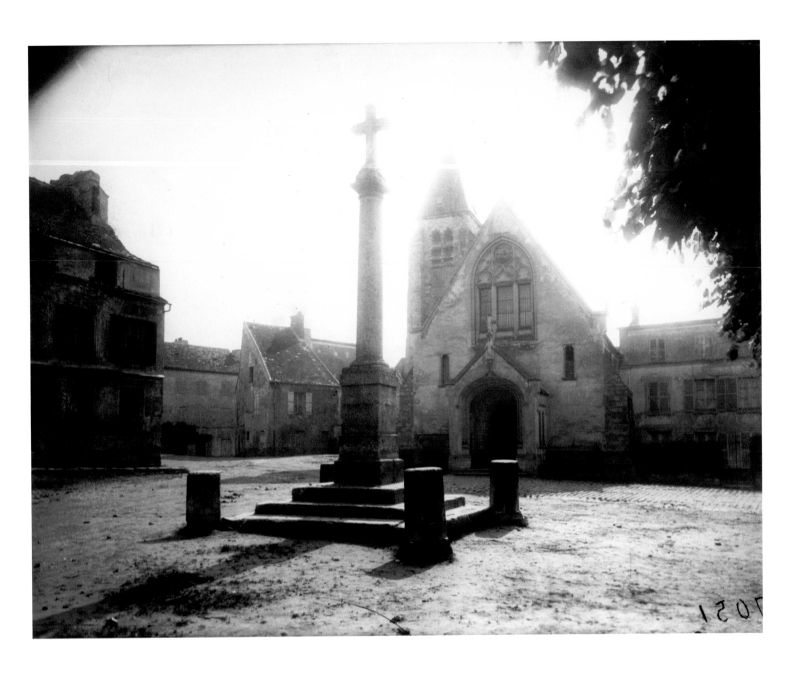

68. *Bièvres (église).* 1924

I would like to back away a little from the suggestion, made in reference to plate 66, that the aging Atget might be thought of as a romantic. He was, rather, a person of fundamentally classical temperament, a person who wanted to make his statement as clearly and precisely as possible, within the given boundaries of his craft, and as he understood that craft. I think that he was uninterested in striving for artistic effect or for personal expression, and that he made photographs only to describe as well as he could the nature of his subject, as he saw it. He had no interest in glints and shadows, or shimmering mysteries, except to the degree that they were inherent in the subject. His art was based on the identification and clear description of significant fact.

And yet, especially in his later work, it is sometimes difficult to describe with reasonable confidence exactly what it is that he thought he was photographing. In the present case, this is an odd way to photograph a very interesting column capital, and an equally odd way to photograph a much less interesting statue of the virgin, and it is surely an unsatisfactory way to describe the physical space of the church.

It is however a compelling picture. One might propose that the real subject is a problem in pictorial balance; note how the right half of the picture—a little piece of white in a field of black—has equal weight to the left half, with its modulated field of grays. But the picture is surely more interesting than a design exercise. Perhaps it might be closer to the mark to say that the picture is about being in a cool place on a hot day, or about sanctuary from the threat of the outside world.

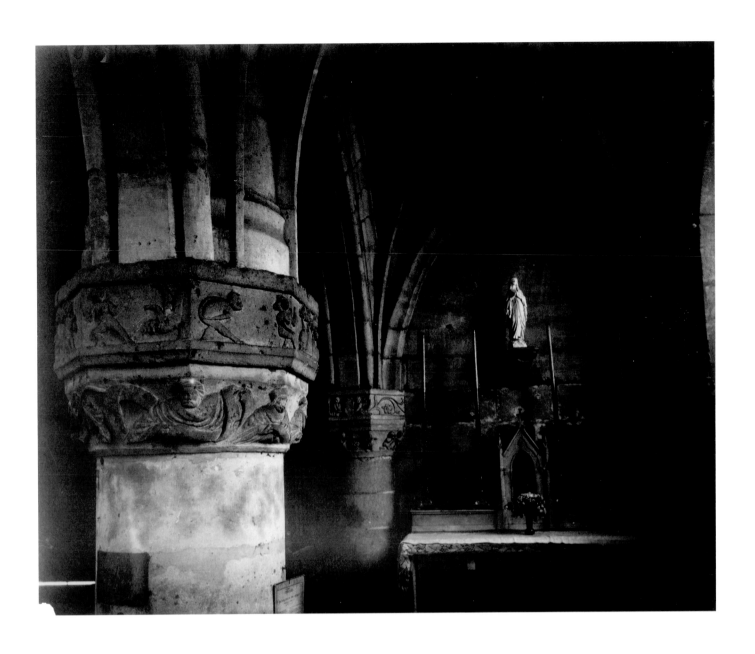

69. *Arcueil-Cachan.* (May–July) 1915

Berenice Abbott (as I have already said) left Ohio in 1921 to study sculpture with Antoine Bourdelle. Rather early in the decade she took a job with Man Ray, and lost interest in sculpture. In 1925 she first saw the photographs of Atget, and lost interest in Man Ray. Atget's pictures changed the course of her own photography, and also the course of her life. After Atget's death in 1927 she managed to buy (with financial help from Julien Levy) the remains of Atget's archive. She negotiated the purchase with Atget's executor and old friend André Calmettes, who also provided her with much of the concrete information, true or false, that we have on Atget, beyond what is contained in a few ounces of documents.

After Calmettes, Abbott is surely our next best source for the historic Atget, and after her Man Ray, and then perhaps Julien Levy. One of them, perhaps Abbott, said that Atget preferred to photograph in the early morning. In the beginning this may have been in part because if he rose early enough he might be relatively free of the pedestrians and teamsters who complicated the problem of photographing in the city. But after the war, Atget worked more and more during the first and last hours of the day because of their beautiful qualities of light. Often that light was delicate and subtle, but in *Châtillon, glycine* it is as subtle as a firecracker. The sun is just above the horizon; it thunders down the street at eye level, strikes the painted shutter, and bounces, true as a billiard ball from the cushion, into the camera's lens. Or could it be just before sunset? That would mean that the wisteria was espaliered on a north-facing wall—not impossible, but a circumstance unlikely to have produced so rich an efflorescence.

70. *Châtillon, glycine.* (1919–21)

The house shown here boasts two birdcages in the doorway, against only one for the house in plate 67; this place would also seem to have a slight edge in potted geraniums. One might guess that there was an unofficial and unannounced competition in such demonstrations of sensibility, similar to that which now obtains in American towns in the ornamentation of one's house with Christmas lights.

Twenty-seven varieties of domesticated canary were recognized by French breeders by the early eighteenth century, and presumably additional progress had been made during the next two centuries. Nevertheless, they appear to have been optional in the quotidian life of rural France in Atget's time. Potted geraniums, on the other hand, were *de rigueur*.

When there was no other handy label to categorize Atget's many photographs of anonymous, intimate public spaces, he would call them *coin*, which can mean corner, or intersection, or angle, or the thing that Atget meant, for which there is no English word, but which we might call an outdoor nook.

71. Sceaux, coin pittoresque. 1922

Husbandry—traditional agriculture—is largely of matter of fences, hedges, moats, walls, and gates, all designed to keep some things out and other things in: the cows in the pasture and out of the grain, the fox out of the hen house, and traveling minstrels out of the orchard. In an ideal world there is a place for everything, but in the real world all things tend to migrate to places where they do not belong, and are kept, approximately and provisionally, in their proper places only by constant vigilance and unremitting labor.

Entrée pittoresque, Châtillon is a picture of one battle in this ancient war. The battle will soon be lost. The decaying door closes against a jamb that is mostly sawdust. A determined small dog could have breached this door on the day that Atget made the picture, but he was not likely to have tried, since this wall and door had a long-standing reputation for impenetrability.

Atget calls it a picturesque entrance, and this is surely correct, but it raises a question: Why is this entrance more interesting to us here, in its penultimate decline, than it would have been when new and clearly competent? One might say that the textures and shapes in this picture are more interesting than they would have been a half-century earlier, but this might be less an answer to the question than a restatement of it. Perhaps it might be more to the point to remember Horatio Greenough's definition of character: it was, he said, the record of function.

72. *Entrée pittoresque, Châtillon.* (1921–22)

It is remarkable how often photographers and critics of the modern period, when coming upon Atget's work for the first time, have assumed that he was a nineteenth-century photographer. In fact, only a small fraction of his work was done at the end of that century, and the greatest of it was done in the decade of the nineteen twenties, during the same years that Man Ray, Imogen Cunningham, László Moholy-Nagy, Paul Strand, Edward Weston, Aleksandr Rodchenko, André Kertész, and others were defining the character of photographic high modernism.

It is surely true that Atget's pictures do not have an obvious high-modernist look to them, but it is also true that they do not typically look like nineteenth-century photographs. They do not have the object-centered directness about them that we expect from nineteenth-century pictures; they are somehow tangential, provisional, relative. Atget stands in a different place than the place where nineteenth-century photographers stood. For this picture he stands not in a place that will isolate the characteristic shape of the individual cypress, but instead in a place from which the trees and bushes and shed and fence make one beautiful mark on the page.

During the same summer or the next he made a very similar picture out of fancier materials (plate 82). Since Atget numbered the two pictures in two different sections of his file, we do not know which version came first. In a larger sense, neither came first; both came quite late in a long, continuing experiment.

Atget titled this picture *Cyprès*, but he might have called it "Clôture blanche," in which case we might have noted that it was made six or seven years after the great Paul Strand picture *White Fence*, which Atget surely never saw.

73. *Cyprès.* (1921–22)

This picture shows the entire length of the rue des Chantres in Paris, which makes it seem a very short, dark street to be dedicated to a subject as important as singers. But *chantres* here probably means specifically singers of religious music, and it is a very good street for that. The Gregorian plainsong would reverberate upward against the ancient stone walls, and when the singers faced up the street they would see something similar to Atget's framing of the steeple of Nôtre-Dame.

At the end of the block, the rue des Chantres runs into the rue Chanoinesse, the street of the canonesses. They were the groups of women whose standards of serving God were very demanding, but perhaps not quite so demanding as those of nuns. Typically, a canoness might take the vow of celibacy but not the vow of poverty—but not, I believe, the other way around. Rules doubtless varied from order to order, but we can hope that in this neighborhood there was no vow of silence, so that the *chanoinesses* could turn their processions down the rue des Chantres, and hear their praises bounce up the walls toward heaven.

This is the oldest part of Paris, but even here time will not stand still. Atget had made a photograph from this vantage point more than twenty years earlier, and at that time the streets were covered with paving stones, but in 1923 they were paved with some plastic coating, perhaps a variety of macadam. This was a blessing to the men and horses who pulled carts and wagons up the hill, but it was bad luck for photographers. Each paving stone took the light beautifully, and together they defined precisely the plane of the street.

Eight years later André Kertész made a picture from the same vantage point, which he called *Rue des Ursins*. Kertész (as was typical of his somewhat coquettish vision) included only a sixth of what Atget had included.

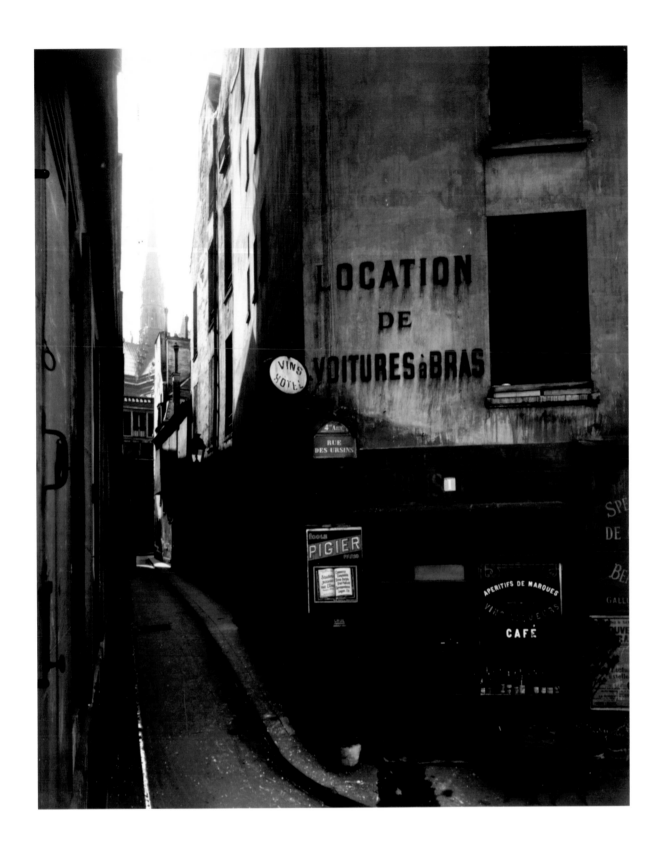

74. *Rue des Chantres.* (April–May) 1923

In the nineteen thirties Le Corbusier gave a series of lectures in the United States, in which he claimed that New York was (in some ways) a great city because it was built with streets at right angles to each other—a mathematical grid of great *clarté* and *rationalisme*. If a Parisian wanted to go from his home to the Luxembourg museum it was first necessary to consult a map and devise a route. Old gentlemen pretended to find this the charm of the city, but Le Corbusier thanked Louis XIV, Napoleon, and Baron Haussmann for having imposed a degree of order on the city.

It is well known that architects without commissions in hand will say almost anything to attract attention. It is also true that Le Corbusier did design a plan for a new Paris based on this premise. If executed, his scheme would have made Haussmann's near destruction of old Paris, two generations earlier, seem positively timid. It should be said in Le Corbusier's defense that he surely understood that the French would never stand for such an atrocity.

The tiny building at the tip of this island between the rue de Seine and, perhaps, the rue de l'Échaudé is an interesting example of what happens when one does not have the *clarté* and *rationalisme* that come with streets laid down in a right-angle grid. The building shown here represents a very large investment in masonry per square foot of interior space; in comparison, even New York's Flatiron Building is a monument to greedy efficiency. Nevertheless, it is hard to believe that even an architect would be willing to tear it down.

Atget had photographed this corner on two earlier occasions over almost twenty years, and on this May morning he made two negatives. The first one was made from the middle of the street, looking straight into the island's point. The oblique view shown here emphasizes the rapid foreshortening created by the wide-angle lens, and the island seems to have changed into a ship, moving at great speed.

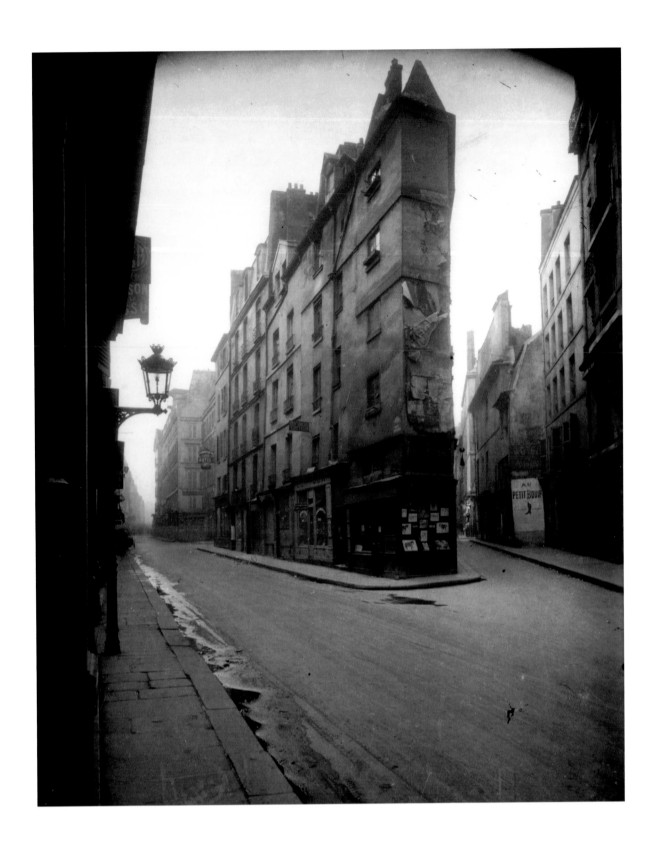

75. *Un Coin, rue de Seine, mai 1924*

Two years earlier, also in March, Atget had made a very good picture of the Pantheon from almost the same spot as the one he chose here. The 1923 picture was made late in the afternoon, and a sliver of sunlight struck the stones of the rue Valette. The first picture was vertical, and included the whole lantern of the dome. When he returned two years later he came early in the morning, turned his plate to horizontal, decided he could sacrifice the dome's lantern, moved three steps forward, and made what must be the best picture yet made of the world's second Pantheon.

The Pantheon of Paris was built in the late eighteenth century as a church, and was consecrated to the patroness of the city, Sainte-Geneviève. With the arrival of the Revolution, the building—because of its classical style and youth—did not carry the same heavy load of negative associations as the ancient Gothic and Romanesque churches, so rather than being vandalized it was given its new name and adopted by the government as a place to worship—or rather, pay homage to—the nation's great men, most of whom would be named later. It was reconsecrated in 1828 and again in 1851, and resecularized in 1830 and again in 1870. Its current status may well prove to be permanent. In consequence of its tergiversating history it would seem—almost alone among Paris monuments—to have no definite political coloration.

Maria Hambourg has pointed out that Baron Haussmann widened the rue Valette by tearing down the buildings that formerly stood on the right side of the picture, in order to provide a more open view of the Pantheon. This is not always a good strategy; many Romophiles feel that St. Peter's has never looked so spectacular since Mussolini pulled down the dark and narrow, slum-lined streets that led to it, and from which one got one's first look—like a blow—of its blinding dome. In any case Atget managed to defeat Haussmann's idea by moving far to his right, and thus narrowing the visual window.

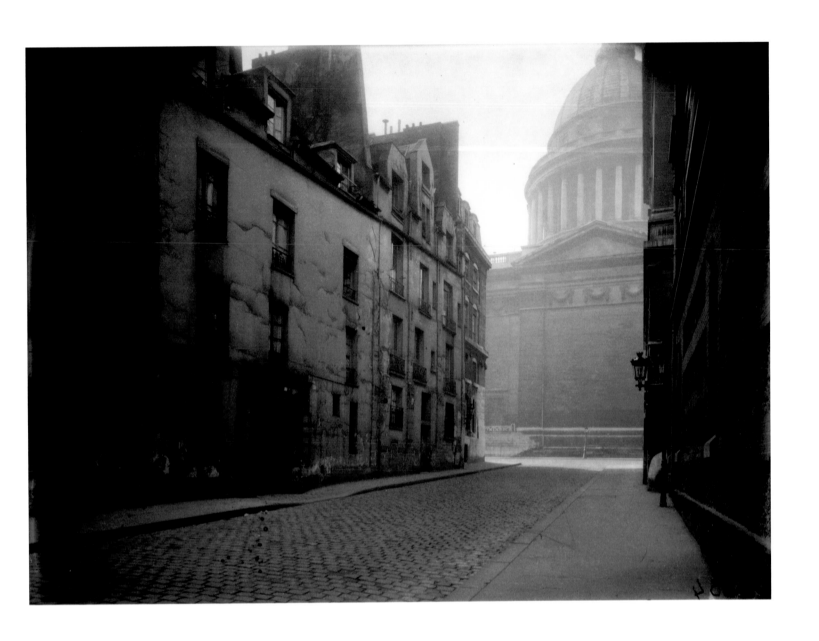

76. Coin de la rue Valette et Panthéon, mars 1925

In his last years Atget began to date his work, not regularly, but with fair frequency. This departure from what had been his normal practice seems surprising. It came at a time when he had achieved some financial independence, and had given up most of his commercial practice. He seems to have been working, as photographers say, for himself. We cannot suppose he was dating his work for posterity, but from a purely documentary point of view (as that notion is generally understood) it isn't easy to understand why one need know that this picture was made in April.

It was noted earlier that Atget tended to work close to his subject, and thus generally preferred short (wide-angle) lenses. This tendency was often reinforced by the nature of the technical problems that Atget faced. Beginning in 1906, and until 1912, he spent much and sometimes most of his energies pursuing a profitable but routine assignment of documenting, sometimes door-to-door, the buildings on certain Old Paris streets. In the cramped quarters of those streets the photographer must either show the facade from a very oblique angle, with a normal lens, or move closer to a head-on view and use a wide-angle lens. The wide-angle solution will provide more information about the building, but it will also produce a picture with extreme, unfamiliar foreshortening, suggesting a structure that is rapidly disappearing into the distance, as in the paintings of de Chirico, or in plate 75. Atget learned to control the disorienting effects of the wide-angle lens by anchoring the drawing of the picture—its linear constitution—in a solid graphic pattern. He re-established, by the disposition of his masses, the equilibrium that had been threatened by the extreme perspective drawing of the wide-angle lens.

Here, this business of reclaiming pictorial stability from the threat of deep space seems almost to have become a conscious game. The shape of the dark square, resting on its corner, like a baseball diamond, contradicts the swift rush toward infinity, and brings the life of the picture back toward two dimensions. It is a game of two-dimensional geometry, rather like billiards.

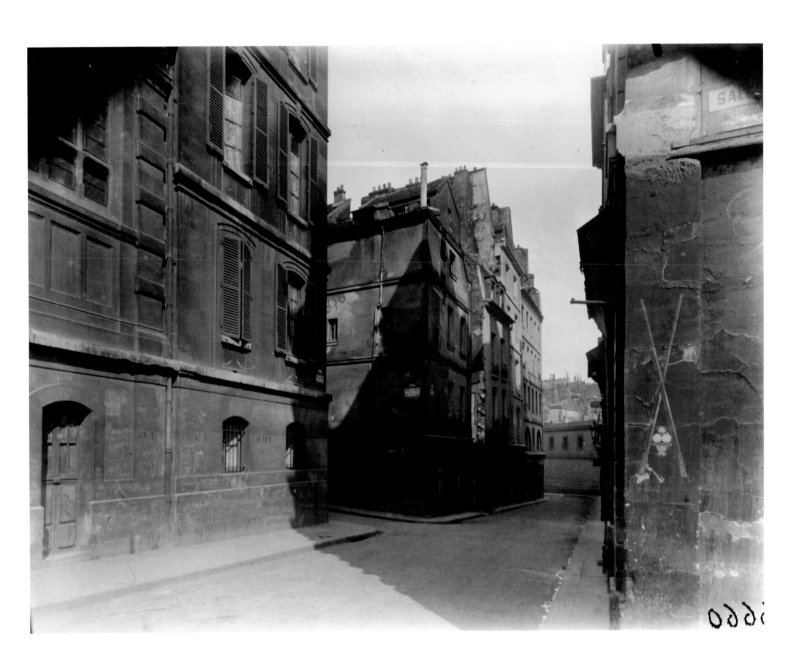

77. *Rue Descartes, avril 1926*

The terrible limitation of photography—the fact that it can picture only what is here and now—forced it to invent a new kind of poetry to deal with the past and the future. It was a method of suggestion based on ellipsis and absence.

I do not think that empty chairs meant the same thing before photography as they mean to us now. Hippolyte Bayard, one of the several inventors of photography, made, probably in the late 1840s, an excellent photograph of various objects in his garden, in which an empty chair played an important, but not quite a starring role. Perhaps photography's first great empty chair was the one that Alexander Gardner made of Abraham Lincoln's rocking chair, with each rocker balanced on a separate, tiny pedestal to make clear that it would never rock again. Painters and sculptors could paint or sculpt the Great Emancipator himself, even after he had been sealed in his tomb, but Gardner could only photograph his chair.

This picture is less about Paris than about its generation of fans who came between the Great War and the Great Depression to sit in the cafés, contemplate life, attempt art, find love, and enjoy the favorable currency exchange. Atget made his photograph early in the morning, while they were absent.

78. *Café, avenue de la Grande-Armée.* (1924–25)

The best photographers go to bed early, and are up before sunrise. They may miss the evening light, but on the basis of photography's evidence the dawn appears to be even better.

From Atget's apartment in the fourteenth arrondissement, a trip to the rue de l'Abreuvoir in the eighteenth was a journey across most of the city, from south to north. He must have traveled in the dark to get there, which raises an interesting question: Is this what he came for? A bright line of wet cobblestones surrounded by mist and shadow? Perhaps he was on the way to photograph something that he could put a name to. He was just around the corner from the Lapin Agile, which had once been a favored drinking place of artists and which Atget had photographed in at least three different years. The rue de l'Abreuvoir is a short street, on top of the butte Montmartre, up the hill from the place Pigalle. In fact, it is only one block long, so we know almost exactly where he was standing. He was looking straight toward the basilica of Sacré-Coeur, which is surely the dome at the end of the street, almost hidden behind the trees.

79. *La Rue de l'Abreuvoir.* (March–May) 1925

Saint-Cloud was the seat of Louis XIV's brother Philippe I, duc d'Orléans, called Monsieur, and it stayed in the hands of the Bourbons long enough for his great, great grandson, the unlucky Philippe Égalité to have grown up there. However, the equally unlucky Marie-Antoinette bought the place from Philippe's father in 1784, which perhaps explains the allegation that the younger Philippe and Marie despised each other.

After the Revolution a long succession of important people lived there, until 1870, when the Prussians sacked and burned the place. This allowed Atget, a half-century later, to concentrate on André Le Nôtre's gardens.

Atget began work at Saint-Cloud in 1904, three years after he had first photographed Versailles. He had already learned how to make a simple and forceful picture from the elements of which the parks were composed: dark trees, white stone, water, light, and space. This was simply a matter of standing in the right place at the right time, and of framing from that place a segment of the world that looked and felt coherent and meaningful. Part of the trick was in learning to avoid, or at least distrust, the vantage points that had been supplied by the parks' designers: the vista from the foot of the allée or the head of the stairway always (for a camera) had too much empty foreground and unfigured sky, with the interesting material concentrated on a thin strip that covered the horizon. As a first step, the photographer had to find a vantage point from which the interesting parts could be patterned over the whole plate.

Atget had learned these basic mechanical skills before he got to Saint-Cloud. Over more than twenty years it would seem that he scarcely made a weak picture there, and from the beginning he could proceed to explore progressively more unexpected varieties of coherence.

80. *Saint-Cloud.* (1904)

Whether or not Louis XIV ever actually said *L'état c'est moi*, it was surely as true as he could make it. His taste for control was not restricted to what we might think of as matters of state; if he was God's regent in France, there was no reason why even the trees should not acknowledge his authority—not only at Versailles, and at Saint-Cloud, his brother's place, but in every garden that acknowledged its status as a satellite of the Sun King's garden.

In Louis's time, the chief responsibility for defining the proper attitude for gardens was borne by André Le Nôtre, a great favorite of the king. In Le Nôtre's very old age he would be carried about Versailles in his own sedan chair, side by side with the king's chair. Alas, it is not known what they discussed.

But even before the king and Le Nôtre were safely dead a liberal reaction began to be heard, and by the early eighteenth century, Joseph Addison, in Richard Steele's *Tatler* magazine, complained that formal gardens gave us not orchards in flower, but "Cones, Globes, and Pyramids. . . . We see the marks of the Scissars upon every plant and Bush."

By the early twentieth century, the idea of Le Nôtre's gardens had been infected beyond cure by later notions of the virtues of nature. The great lush oak, behind the three cones in this picture, did not exist, nor would it have been permitted to exist, when the park was new, for its romantic asymmetry contradicted the goal of subjecting the botanical world to geometrical perfection.

Atget's photographs subverted the classical idea even further. Their insistence on the elliptical, eccentric, provisional vantage point, and their consistent avoidance of the prescribed axial views turn Le Nôtre's geometry into something wilder.

81. *Saint-Cloud.* (1921–22)

The big oak behind the three cone-shaped trees in plate 81 was a thing of continuing interest to Atget for a period of at least three or four years, during which he made not fewer than eleven photographs in which it was a conspicuous part. In his work after the war it was not unusual for Atget to return to the same tree over an extended period, but in most of these cases it is the various aspects of the tree itself that is his subject. In the present case, the tree remains almost constant; we recognize it at once from its distinctive and extraordinarily expressive silhouette. What changes is the architectural context; the tree, fundamentally the same, reappears as theme, the architecture as variation.

Or, one might think of these pictures as a series of dialogues, or duets, between artifact and nature.

Of the eleven identified pictures that include this tree, this one was the last. Perhaps the photographer felt that he was unlikely to do better than this, and that the picture fairly summed up what he had been working toward. Or perhaps he thought that about the picture of the cypress and the white fence (plate 73).

82. *Saint-Cloud.* (1922)

Atget first tried this motif in 1904, but there was too much wind, and the reflection of the trees in the water was mushy. He tried again sometime between 1915 and 1919 —probably in 1919—and almost surely early in the morning (since this time the water was still and the reflection crisp, and since after the war he rose earlier to get the best light, and perhaps because sleep came harder). On that second try however he did not get all of the reflection. It is cut off by the bottom edge of the picture. This turns the reflection into foreground, as you will see if you place a business envelope over the bottom quarter of this later version of 1921. With the envelope it is still a good picture, but it is more familiar, more material and earthbound. It is clear that Atget considered the earlier framing a mistake; in the next seven years he made many photographs of the reflections on the ponds of Saint-Cloud, and in all of them, as here, the reflected trees float on the same flat background as the real trees.

When we attempt to discuss the life of pictures we allow ourselves to speak of real trees and reflected trees; we extend to ourselves sufferance to speak imprecisely, rather than repeat over and over again, tediously, that there are no real trees here, or reflected trees either, that there is only aspect. Photographs are about aspect, but the best of them make us half forget the fact.

83. *Saint-Cloud, matin, 6 ½ h., juillet.* (1921)

The fountains of Versailles were designed without regard for the fact that the place had very little water, and the effort to bring it in (including the construction of ninety-eight miles of canals) constituted a great and immensely costly engineering effort—even if some might think it a frivolous one.

Saint-Cloud, on the other hand, was blessed with plenty of water, and Antoine Le Pautre used it well in designing the Grande Cascade, an artificial rapids that might have served in principle as the inspiration for the modern fish ladder. The cascade is an extremely dramatic event; it is to the parc de Saint-Cloud what the *Mona Lisa* is to the Louvre: a superb crowd pleaser. Like Niagara Falls, though on a smaller scale, it represents an undeniable force of nature, and it is also a work of art.

Surely every photographer who worked at Saint-Cloud photographed the Grande Cascade, generally head-on from the foot of its collecting pool. Atget photographed it too, breaking it up into a collection of details, and then, duty having been done, proceeded to make deeply evocative pictures on the periphery of the main attraction. The stairway here leads to the bridge that crosses over the source of the cascade. The sculpture to the left of the large tree is an allegorical pair representing the river gods of the Seine and the Marne; the two figures hold the great urn from which the waters of the cascade pour.

If the wind blows upstream the cascade might throw water on the stairway, and make the sky bright with mist. Or perhaps it is merely the early morning light, the triumph of pure energy over the grosser forms of matter. Considered simply as a photograph, it is typical of the pictures that Atget made as an old man. It is a picture that defines its subject precisely on the border between private sensibility and public virtue.

84. *Saint-Cloud.* (1924)

Maria Hambourg tells us that Atget made most of his photographs from March to October, and saved the inclement months for printing his negatives and for business matters. So this picture was made near the beginning of his last full year of work.

The picture is in feeling much like plate 48, made twenty years earlier at Versailles, except that the later picture is more adventurous in its design, with its "important" parts all piled in the center, and it does not claim an art-historical function. In the earlier picture the statue of Pan, or perhaps Silenus, may well be a routine nineteenth-century copy of a routine sixteenth-century collage derived from Roman elements; nevertheless, it is treated as the major element of the plot. By contrast, in the picture at Saint-Cloud the vases are much less important than the tree, and perhaps even less important than the bicycle.

Directly behind the bicycle is a man who seems to be wearing the sort of military cap—like an envelope slit open on one long side—that the Americans called an overseas cap. The photograph gives us no hint as to why he should be sitting on a bench in the parc de Saint-Cloud at nine o'clock on a March morning, with his bicycle propped against the pedestal of a minor art work.

It has been pointed out that during the first thirty years of his life as a photographer Atget almost never dated his pictures; beginning in the nineteen twenties he dated them not consistently but frequently; often he also gave the month and sometimes, as here, even the hour. It is not at all clear why he did this; surely it was not for the convenience of future curators and historians, although we are nonetheless grateful. Almost as certainly, it was not to satisfy the archivists of libraries; we might guess that, had they had their way, all photographs would have been made at noon on overcast days, to eliminate as nearly as possible the eccentricity of specific moments. And, if Atget was still selling prints to painters, they were surely capable of deciding for themselves whether it was nine in the morning or five in the afternoon, in March or October.

85. *Saint-Cloud, mars 1926, 9 h. matin*

It seems likely that Atget noted the hour at which he made a picture for his own sake—as a matter of information that might be useful to him in planning future trips. Still, photographers normally record that sort of functional information in a notebook, or on the negative envelope, rather than include it as part of the caption. On at least one occasion, Atget also recorded, as part of his caption, his exposure time: *Saint-Cloud, 150 s. vers 9 h. matin, mars 1926*. Perhaps this notation was made to record an experiment: a two-and-a-half minute exposure seems massive, even on a gray March morning.

Atget photographed the same pond seen here four years earlier, from a point of view about forty-five degrees to the left of his position here. It is an excellent picture, but more literal, less luminous; in this second try he has exposed his plate more heavily, allowing the hazy morning light to insinuate itself into every shadow.

Surely it would be wrong to suggest that Atget—sober as a milkmaid for sixty years— became a fantasist in the nineteen twenties. Perhaps one could say instead that the range of his responses grew broader and deeper, and that the facts he described clearly and justly came to include facts of such a surprising character that they might seem almost miraculous.

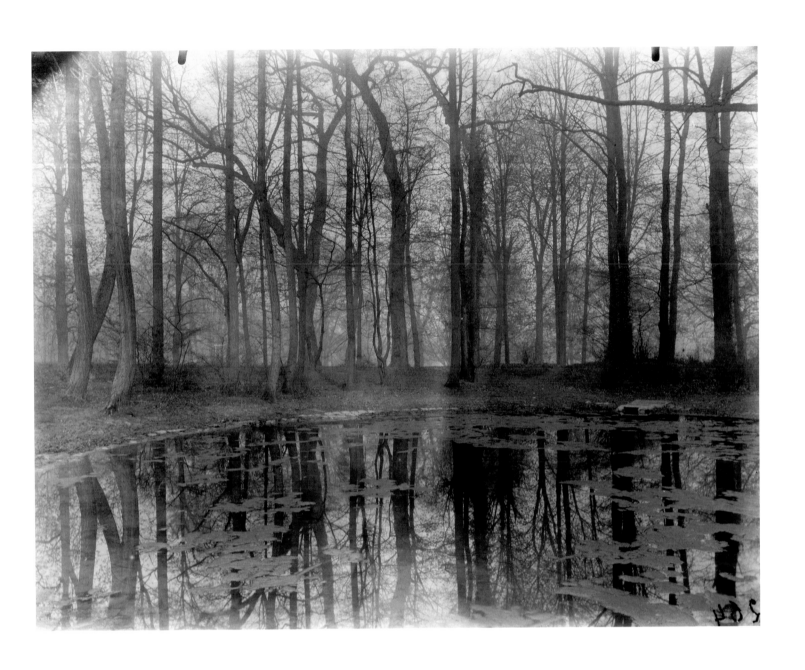

86. *Saint-Cloud, étang, 9 h. matin, avril 1926*

During 1926 Atget made twenty-five pictures at Saint-Cloud, beginning in March and continuing into June. This is the very last of his many pictures of the reflecting pools that began in 1904.

The final few of these pictures are no longer about art history, or landscape gardening, or the visible remnants of the eighteenth century. It is difficult to guess what Atget might have thought they were about. Perhaps they were about the habit of photographing. (A year earlier Alfred Stieglitz had written to the painter Arthur Dove that he was photographing again: "I'm at the game once more—chronic—incurable.")

For us these pictures are about the life of pictures, and surely about some other more specific fact that we will not successfully describe in words, even though we seem compelled to try. One might say that they are about the horizon: the line that marks perspective's farthest cast, that separates the visible from the invisible, understanding from knowing, ambition from longing.

On June 20, Valentine Compagnon died. She and Atget had lived together for thirty years. Their friend Calmettes said that Atget was inconsolable—*désespéré*—but brave, and that he continued to work, although more bent and more melancholy.

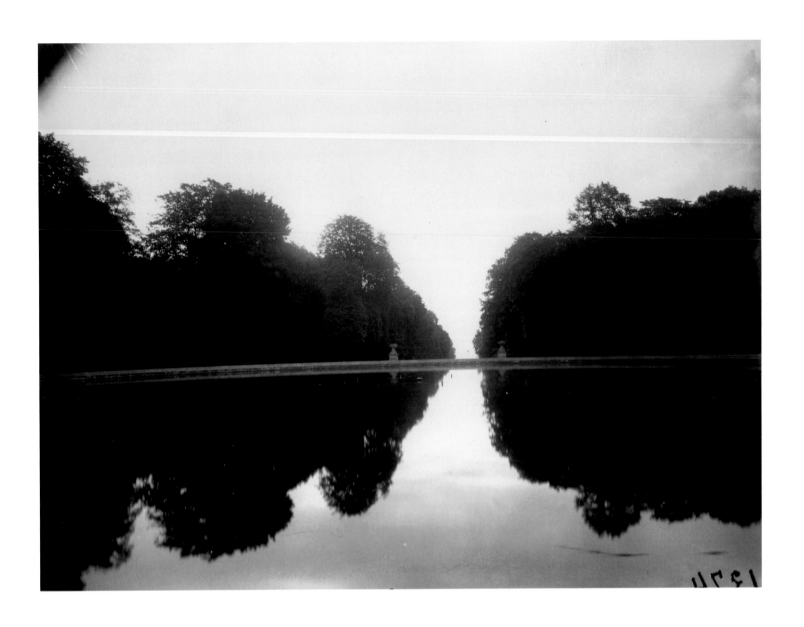

87. *Saint-Cloud, juin 1926*

During most of the history of photography, except perhaps only its earliest years, most of its best practitioners have served the art in secret, while pretending to be gatherers of merely forensic evidence.

Until Atget reached the age of sixty his work can be more-or-less plausibly explained as that of a man who was more talented than his job description required and who therefore satisfied the needs of his customers and, at the same time, often transcended them, and made pictures that were simultaneously utilitarian and splendid.

This seems an adequate explanation—or at least a plausible rationalization—of most of the work that he did during the first thirty years of his life as a photographer, but it seems inadequate as a reason for the making of this image and, in fact, for most of the work Atget did in the twenties. None of the scholars and critics who have been interested in and mystified by Atget (including this writer) have proposed a convincing argument to explain the evident fact that a commercial photographer in his declining years should have changed his goal, and made photographs for which he had no potential buyers.

As with the lamp-shade seller of plate 17, Atget stands very close to this poor crippled simulacrum of a laborer (still in harness despite his impediments) and has us stare down at his useless, pendant feet.

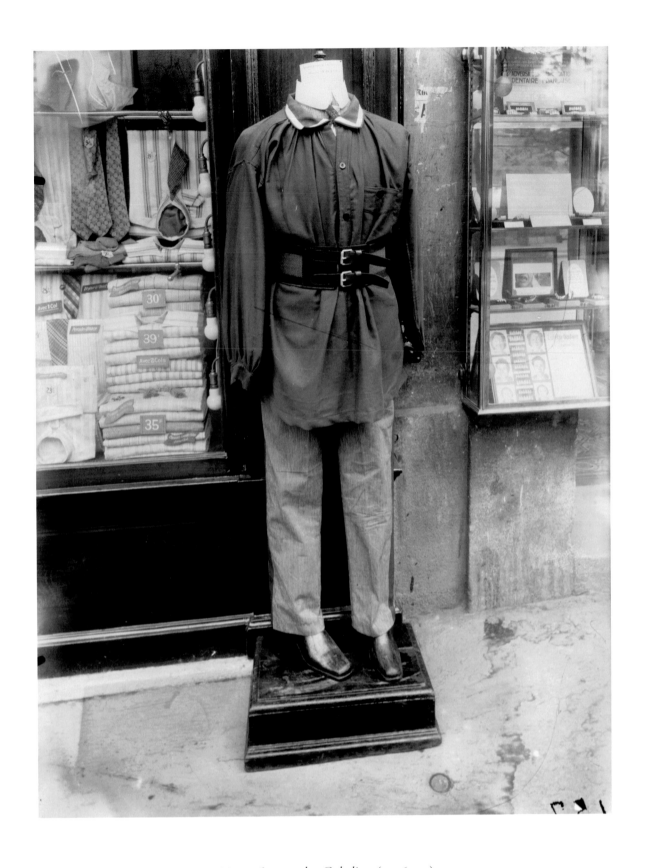

88. *Avenue des Gobelins.* (1926–27)

James Borcoman may have been the first to point out that the domed building reflected in the window is a part of the Gobelins factories, famous for their tapestries (and furniture, paintings, sculpture, etc.) since the time of Louis XIV, when Colbert bought the establishment for the crown and put it under the direction of Charles Le Brun. Called the court painter, Le Brun was really the dictator of the visual arts in France, which were organized and run rather like General Motors, except that there was ultimately only one stockholder. This sort of corporate approach to art making did not perhaps favor the nourishing of individual invention; nevertheless, if the point was to build and furnish expressions of French greatness, such as Versailles, Vaux-le-Vicomte, and Saint-Cloud, then discipline and coherence were more important than originality—perhaps even more important than artistic quality.

Across the street from the Gobelins factory is a department store. Department stores changed the traditional ways of commerce and social interchange, and were therefore perhaps as unsettling and offensive to Atget—on the level of cultural and political principle—as shopping malls have been in our time to photographers such as Robert Adams. Nevertheless, it is wrong and self-defeating to photograph badly the subjects of which one disapproves. In fact, for a photographer as serious as Atget, it might be necessary to photograph a subject as well as he can before he *knows* what he thinks of it.

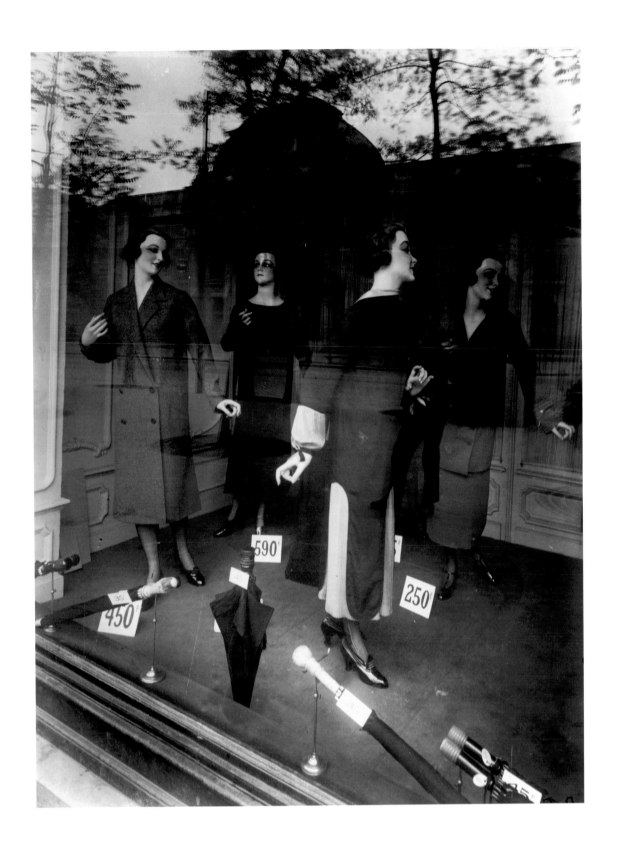

89. *Magasin, avenue des Gobelins.* (1925)

When he was sixty-five Man Ray wrote (in a letter to Minor White) that the reflections in Atget's pictures were unintentional, that they "just came out that way." It is true that the reflections are unintentional in the sense that Atget did not will them into existence; they were formed by the intractable laws of optics and sensitometry. Anyone else who had at that moment put his camera in that precise place and exposed and developed his plate as Atget had would have gotten the same reflections. If that photographer had placed the camera a bit otherwise, or had been a little earlier or later, or had exposed and developed his or her plate a little differently, the reflections would have "just come out" differently. The overlapping of solids and transparencies would be different than they are here, and conceivably no less interesting.

Man Ray was almost exclusively a studio photographer, and was thus not intimately aware of the broader range of possibilities that occur constantly under the open sky.

It is also true that Man Ray, an artist of talent, ambition, and some sophistication, must have become very tired, by the time he was sixty-five, of receiving young visitors who would ask—not about his own not inconsiderable work—but about that of a man who had seemed to Man Ray, when he was young and confident, an interesting primitive. Atget seemed then to belong to an earlier era. In 1927 Julien Levy had learned of Atget from Man Ray, and in 1978 he told Maria Hambourg that he had visited Atget many times during the first half of that year, but that it was Atget's pictures, not Atget, that interested him. The old man spoke in an argot that Levy understood only in fragments, and told long rambling stories of his life as a sailor. But Levy returned twice a week because Atget would sell him only a few prints at a time, so that he might reprint those negatives, and keep his collection complete. Atget told Levy that he was an archivist, but Levy thought he was kidding himself, because archivists do not return to rephotograph when the light is better, which Atget said he did often.

It may have seemed to Man Ray and Levy that the pictures were produced by some impersonal operating principle, of which Atget was merely the innocent agent.

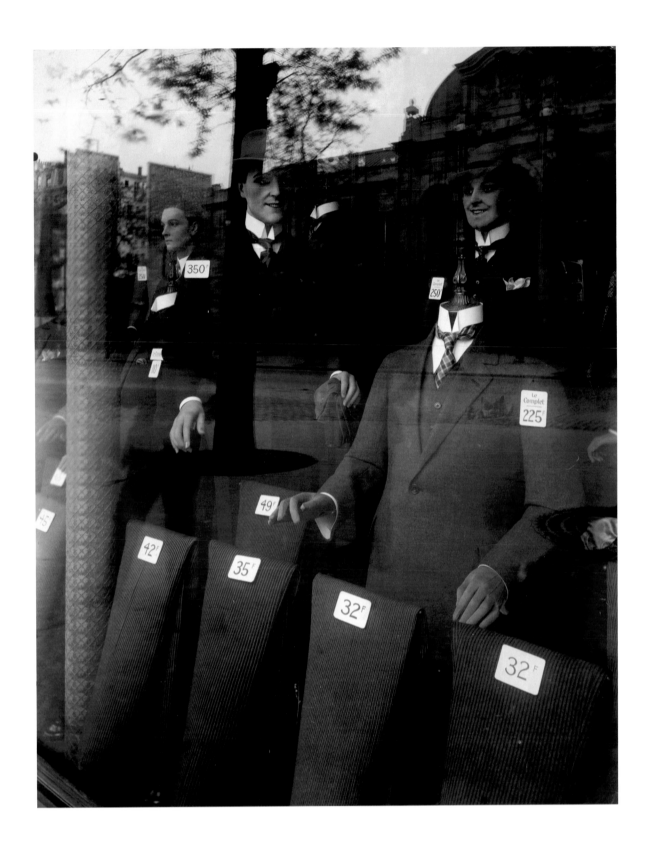

90. *Magasin, avenue des Gobelins.* (1925)

In 1925 and 1926 Atget devoted a good deal of his attention to clothing shops, both in working-class and bourgeois neighborhoods. Presumably, shops catering to working people sell their goods at a smaller markup, and it is therefore not surprising that they should find ways to save money in their display techniques. In Paris in the mid-twenties they did this by omitting the heads on working-class mannequins, and substituting a kind of impersonal, abstract, unisex *tête,* suggesting something between a newel post and the spike on the top of a German soldier's helmet.

The lineup here seems appropriately rank-conscious, and almost military in bearing and uniform, except for the second dummy from the left, who wears a shawl collar. The figure in the middle, with the black tie, is obviously senior in authority, but since he is wearing an apron he must be merely a waiter, not a head-waiter or captain. The others must be simply busboys, *garçons.*

The proportion of six slaves to one vice-factotum seems extreme, but if it is true, as the older generation told us, that it was impossible, before World War II, to get a poor meal in Paris, then perhaps the men in the white jackets—miserably treated as they doubtless were—had at least some sense of playing a small part in an artistic triumph.

The photograph is hard in contrast, almost two-dimensional. The figures are only marginally substantial; one might say that they are merely suits.

91. *Boutique aux Halles.* (1925)

The Old Paris that remained to be photographed by Atget was not of course really old Paris.

The Palais Royal proper was built in the mid-seventeenth century for Cardinal Richelieu by Jacques Lemercier, the cardinal's favorite, and the first of the great architects of Bourbon France. A century and a half later it was greatly expanded and converted to something like a shopping center by Philippe Égalité, the duc d'Orléans, who later, in spite of his most republican name, fell to the Terror.

Sir Charles Darnley visited the place in 1823 and found there "a gay crowd formed of persons presenting the utmost diversity of character . . . who come hither to stare at the articles displayed in the many-colored shops—to eat ice—dine—drink coffee—to be cheated in purchasing clothes, books, or trinkets—to loose their money at the gaming tables, or their health at some of the various temples of vice which abound in these purlieus." But these colorful sorts had abandoned the Palais Royal long before Atget got there. Rowland Strong recommended its restaurants (*Where and How to Dine in Paris*, 1900) only to "people who do not object to dining in company with ghosts."

For those who lack ghosts, the two toupee mannequins (how perfect for their jobs!) should do quite as well.

92. Untitled [toupee shop, Palais Royal]. (1926–27)

Richard Cobb, in considering the lives of the French lower classes during the revolutionary era, decided that in spite of the wretchedness of their condition—very long hours of labor under unhealthy and often dangerous conditions, lack of job security, insufficient and incorrect nourishment, inequality under the law, etc.—that they were still, remarkably, capable of entertaining themselves with enthusiasm and deep carelessness during the hours and occasional days that offered themselves as times of freedom.

A century after the Revolution, conditions were in most ways for most people doubtless improved, but in fact France like other countries was still full of people who worked too hard and too long at tedious or killing jobs, who were routinely malnourished, who had little to go home to, and who would grasp at any entertainment that they could afford that would divert their attention, for a moment, from their own unpromising situation.

Atget understood the bargain, for he had been complicit in it—in the irrational forgetting of long-term truths for the sake of short-term pleasure. He had spent a decade of his young manhood as an actor, attempting to amuse bumpkins and wage slaves in third-rate theaters, horse barns, or village squares; if successful, he would distract them for an hour from the realities of their condition. On good nights he might even distract himself from his own.

93. *Fête du Trône.* (1924)

It would seem that the brass ring that one attempts to catch while riding a carousel originated with an idea of Pope Paul II (1464–71), who, in an effort to bring some degree of control to the pagan licentiousness that characterized carnival—the period before lent—designed organized games, with prizes, including one that offered four silver rings to be awarded to those horsemen who were most adept at snaring them with their lances. He also organized races among various groups, including Christian young men, Jews, sexagenarians, and buffaloes.

Later in the Renaissance the idea split in two—one branch becoming a species of competition among knights, and the other an amusement for children, often also with a competitive component. In the latter case the carousel became a large overhead wheel, mounted on a vertical axle—something like an outsized maypole—from which the players, hanging from long tethers, would attempt to knock the hat off an elected villain.

Such games were presumably for older children; for the younger ones in a marginally more civilized time, riding a carved rabbit was exciting enough.

These rabbits and horses have not been affected by Eadweard Muybridge's photographic evidence of a generation earlier, and they continue to gallop with all legs extended, as animals in art had galloped since the days of the Assyrians. The rabbits here look us squarely in the eye, as though inviting us to challenge the way they run.

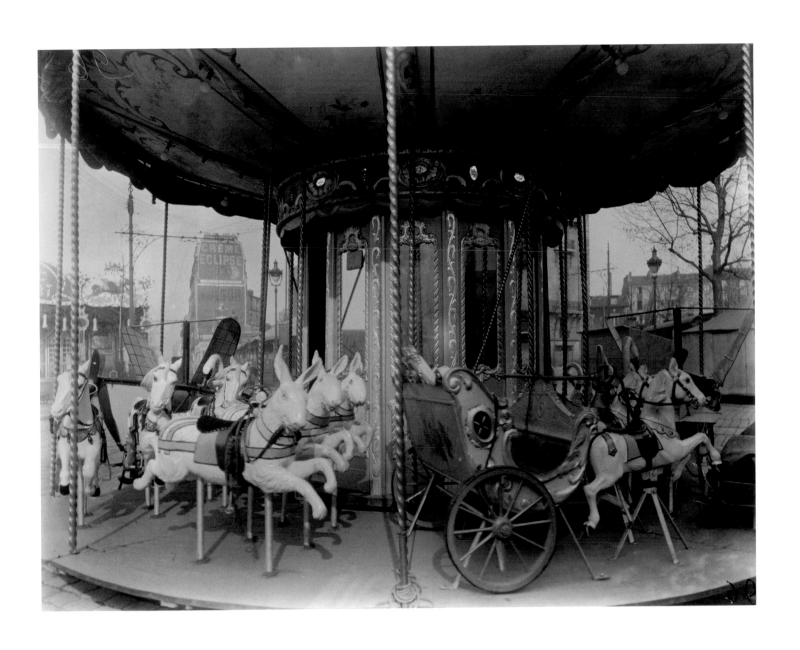

94. *Fête de la Villette.* (1926)

The author of the Book of Numbers reports giants so large that he was as a grasshopper in comparison. At the beginning of our own era, Pliny the Elder wrote confidently of earlier races of genuinely gargantuan men, and, even in Massachusetts, Increase Mather (the principal Calvinist of his time and president of Harvard) is said to have sent a tooth weighing more than four pounds to the Royal Society, as evidence suggesting that before the flood there had indeed been very great men.

By Atget's time most people no longer believed in giants much bigger than basketball players, and in order to make Armand seem truly awesome it was necessary to show him alongside the Smallest Person in the World. (Our belief in midgets, dwarfs, and pygmies has grown stronger as our belief in giants has declined.)

Atget made many pictures of local street fairs, and in his last years this subject is especially conspicuous in his work. It is interesting that Atget seems never to have attempted to photograph Armand and the little man, or any of the advertised attractions referred to in the painted fronts.

One of the excellent photographers of the firm Séeberger Frères sometimes photographed the cast of players on the outside platform before the barker sent them inside, and the players are wonderful to see. In the same years the German photographer August Sander made superb portraits of circus people during moments of leisure. But when Atget photographed the street fairs he attempted neither reportage nor portraiture. He had a different idea, or a different intuition; he was enchanted with the *mise-en-scène*, with the stage perfectly arranged and electric with promise before the first player has stepped onto the boards. Perhaps this makes it our stage.

In Atget we are the visitor at the *fête* (wondering what we might see for our franc), the shopper in the market, the idler hesitating before the door of the bistro, and the merchant confronting his bed.

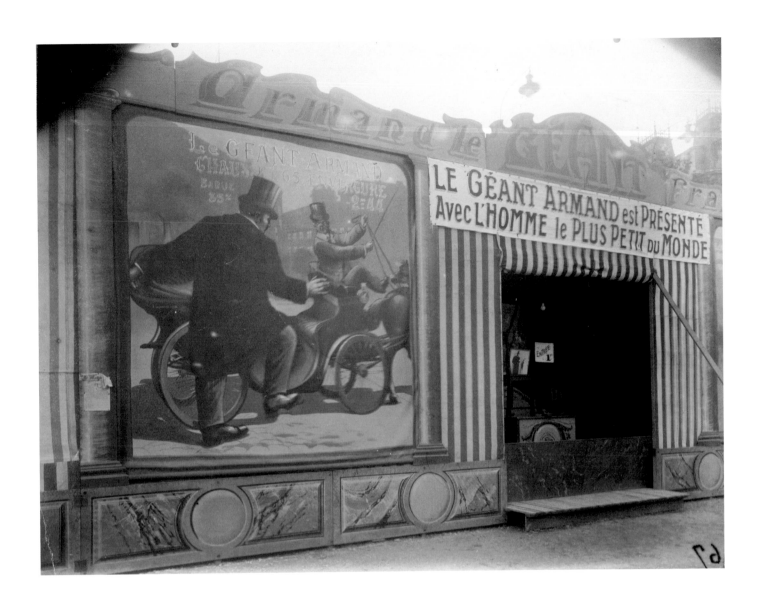

95. *Fête du Trône.* (1925)

It is said that Man Ray claimed to have discovered Atget. It is not altogether clear what he might have meant by this. Even if *discovered* is taken to mean noticed by painters, we know that many painters, including modernist painters, had bought and used his work before Man Ray arrived in Paris.

Man Ray's interest in Atget was perhaps of a different order. Man Ray's virtue as an artist is surely not dependent on his visual sensibility (on what artists refer to when they discuss and evaluate the character and quality of a colleague's eye) but, rather, on his poetic sensibility—his alertness to literary ideas that might be yoked to some consonant visual expression. In terms of this artistic ambition, a part of Atget's work would have been for Man Ray a great source book for that aspect of its content that can be read as the illustration of disjunction and incoherence.

In 1926 Man Ray acquired several prints from Atget for reproduction in *La Revolution surréaliste;* or possibly the magazine published in that year several pictures by Atget from the substantial collection that Man Ray had acquired over several years. A half-century later Man Ray was interviewed on various issues by Paul Hill and Thomas Cooper. Among the subjects touched on was Man Ray's relationship to Atget. One of the questions not specifically asked in the interview's published form, but implicit in the larger question concerning the relationship between the young man and the old one, was: Why was Atget not credited as the maker of the photographs? Plausible answers might have included, It never occurred to us, or We didn't normally do that. But Man Ray's answer was that Atget did not want credit or publicity, since his pictures were *simply documents.* This non sequitur is not likely to convince other commercial photographers or other artists, who surely share a high respect for proper credit. In fact, the rest of the interview is full of dubious claims and demonstrable falsehoods; in the unlikely event that Man Ray's recollection of the conversation regarding credit was reasonably accurate, we must assume, I think, that Atget was, once and uniquely, dissociating himself from a client. It is not inconceivable: I should think that he would have little sympathy for an artistic idea predicated on the notion of giving offense to the bourgeoisie.

Even if Man Ray's recollection (and his interviewers' report of it) was accurate, the remark itself is hopelessly ambiguous. Much too much intellectual energy has already been wasted on trying to make gold from this pyrite.

On the same occasion Man Ray said, "He was a very simple man, he was almost naive. . . . I don't want to make any mystery out of Atget at all." This is perhaps not incompatible with what he had written twenty years earlier to Minor White, in connection with a discussion of the adequacy or inadequacy of Atget's technique. Man Ray said then, "I think he was an artist, not a perfectionist."

96. *Fête du Trône.* (1925)

I n fall 1924, while photographing villages to the south of Paris, Atget found his perfect subject—a perfect ruin, where the ghost of a former world lay tangled in the shards of a former garden.

On that occasion he photographed only the entrance gate, but it seems likely that he reconnoitered the grounds, and remembered them through the winter, for he returned in March to begin what was the most concentrated and the most consistently extraordinary body of work in his entire career. From March through June he made (or saved) sixty-six plates, numbered ten through seventy-five. None of them is perfunctory or dutiful; they persuade us that each one is essential, and that one more would be redundant. And yet it would be difficult to say with confidence exactly what their subject is, other than transience and, of course, tenacity.

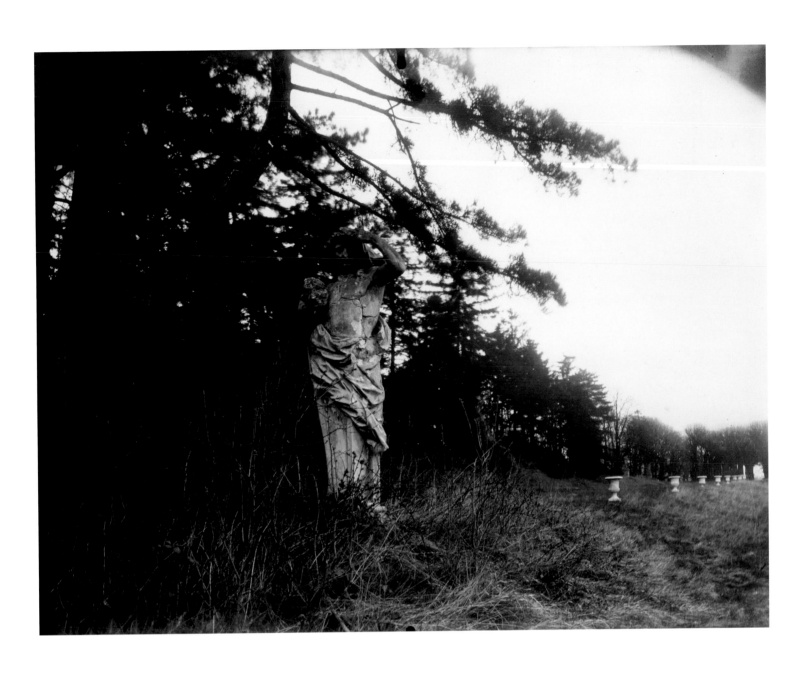

97. *Parc de Sceaux, mars, 7 h. matin.* (1925)

Sceaux was built in the late seventeenth century for Jean-Baptiste Colbert. Its chateau lasted a little more than a century, and was then destroyed during the period of the Directory, the authority that represented the third or perhaps the fourth phase of the Revolution. Colbert was the second of Louis XIV's indispensable men. The first was Cardinal Mazarin, who died in 1661, when the king was eighteen and had been king for thirteen years. It is said that when dying he told Louis that he, Mazarin, owed him everything, and that he was repaying the debt by leaving him Colbert.

Colbert immediately justified Mazarin's faith by preparing the case against Nicolas Fouquet, the superintendent of finance, for embezzlement. His unforgivable sin was not that he had dipped deeply into the public coffer, which he had, but that he spent the money in a way that was not merely outrageously ostentatious, but more outrageously ostentatious than the king's way. When he held the house-warming for his own new chateau, Vaux-le-Vicomte, he presented a new play by Molière and a dinner for six thousand on gold and silver plates. Lack of sensitivity on this scale could hardly be ignored.

The good news was that once Fouquet was in prison, the king inherited Fouquet's artistic staff: Louis Le Vau in charge of architecture, Charles Le Brun as head painter, and André Le Nôtre as chief of the gardens. These were the people who were responsible for Versailles, plus Fouquet, of course, for providing the example that had to be bettered.

One can hope that this was of some consolation to Fouquet during the fifteen years that he spent in prison, where he died in 1680.

Colbert himself died three years later, at the age of sixty-four. Had he lived longer, things might have gone better for his king, who was still only forty-five, and who would still be king for more than thirty years, with no Mazarin and no Colbert.

98. *Parc de Sceaux, vase, avril, 7 h. matin.* (1925)

L ife in any period, in any country, or on any wild island, was never half so good as it has been made to seem in certain pictures or paragraphs of text that celebrate those times and places. Even to take notice of those isolated moments—for example, the cherry hung with snow—is, one could say, an evasion, which by political design or simple cowardice distracts us from, for example, mournful/Ever-weeping Paddington, not to mention the dark satanic mills.

It may be some such sense of guilt that inclines us to distrust pictures as radiant and untroubled as this one, especially if the picture is a photograph, in which we expect to find at least a hint of corruption. Perhaps this picture is saved by the all but impassable road, which reminds us that this is not Eden. Atget knew this; he had not come by carriage, but had walked from the station with his heavy load, and was now mud to the ankles and (at seven in the morning) wet to the knees.

It is unlikely that Colbert would have appreciated the ruins of Sceaux. The beauties of disorder were discovered by the romantic sensibility; what would have seemed to Wordsworth as the advance of nature could only have seemed to Colbert the retreat of civilization. But his disappointment might have been tempered by noticing that some gardener (younger than Le Nôtre) had disciplined these sycamores so smartly—to cast a tunnel of shade on the road.

99. *Sceaux, juin, 7 h. matin.* (1925)

One might think of Atget's work at Sceaux as a recapitulation in miniature of all his work on the culture of old France, a record of the diminishing souvenirs of a foreign country.

Or, one might think of it as a summation and as the consummate achievement of his work as a photographer—a coherent, uncompromising statement of what he had learned of his craft, and of how he had amplified and elaborated the sensibility with which he had begun.

Or perhaps one might see the work at Sceaux as a portrait of Atget himself, not excluding petty flaws, but showing most clearly the boldness and certainty—what his old friend Calmettes called the intransigence—of his taste, his method, his vision. His young friend Berenice Abbott, a skeptic, guessed that he felt a special kinship to trees. At sixty-eight, at seven o'clock on a gray March morning, he may have felt a special kinship with this particular pine—a tree scarred by life and slighted by time, eccentric but still vital and compelling—which should be photographed perfectly, in a way that would match, or echo, its own unrepeatable identity.

This should be done not because it might bring him wealth, fame, power, esteem (then or later), or a higher station here or in heaven, but because it was what he did best, and in fact the only thing left for him to do. He had achieved a little security and had learned that it did not protect him from the inevitable, lonely failure that is our common end. While waiting for that consummation he would do his best work—not for others or for tradition, but to prove to himself that what he saw was true.

The others, and the tradition, were merely the beneficiaries.

100. *Parc de Sceaux, mars, 7 h. matin.* (1925)

The following comments and citations refer to the texts that accompany the plates and are listed by the page to which they refer.

Page 44: The extremely interesting Ferdinand Reyher was a free-lance writer of short fiction, general-interest magazine articles, criticism, plays, novels, and (in his later years) film scripts. He was also one of the few close friends of Bertolt Brecht. It was, in fact, claimed in Germany at least once that there was no Reyher—the name was merely a Brecht pseudonym (James K. Lyon, *Bertolt Brecht's American Cicerone*, Bonn: Bovier, 1978). Reyher's captions for the Addison gallery exhibition were reprinted in the fall 1948 issue of *Photo Notes,* the publication of the Photo League. A substantial portion of Reyher's extensive and almost indecipherable research notes on Atget (and for his lost, unpublished novel, *Tin*) is in the Atget archives of the Department of Photography of The Museum of Modern Art. *Tin* was based on the adventures of an itinerant tintyper, whose character was based on Reyher's understanding of Atget. The notes were given to the department by Reyher's friend, Ernst Halberstadt.

Page 56: Thomas Okey's splendid essay on the art of the basket can be found in the *Encyclopaedia Britannica,* 11th edition (1910–11).

Page 82: For a fuller consideration of Atget's use of his photographs of his own apartment, see Maria Hambourg's essay, "A Biography of Eugène Atget," in John Szarkowski and Maria Morris Hambourg, *The Work of Atget,* vol. 2 (New York: The Museum of Modern Art, 1981), pp. 9–31, and Molly Nesbit, *Atget's Seven Albums* (New Haven: Yale University Press, 1992), esp. pp. 122–23.

Page 84: Concerning the dangers of life on the street in Belleville/Ménilmontant, see S. C. Burchell, *Imperial Masquerade: The Paris of Napoleon III* (New York: Atheneum, 1971).

Page 92: On the relationship of Paris to its river, see Richard Cobb, "Paris and the Seine," from his *Paris and Its Provinces, 1792–1802* (London and New York: Oxford University Press, 1975); repr. in idem, *The French and Their Revolution: Selected Writings* (London: John Murray, 1998).

Page 104: The information about the commerce in *osier* comes primarily from the *Transaction of the American Institute of the City of New York for the Year 1852* (Albany, 1853), p. 362.

Page 114: See Heinrich Wölfflin, "Comment photographe les sculptures," in Rainer Michael Mason et al., *Pygmalion Photography: La Sculpture devant la camera 1844–1936* (Geneva: Cabinet des Estampes, Musée d'Art et d'Histoire, 1985). I assume that the piece was written in German; if so, the translator seemed not to be identified. The same excellent volume also reproduces Piranesi's Mercator-projection etching of the Borghese vase.

Page 116: Negatives with higher negative numbers, made in the same year and recorded in the same section of Atget's filing system, show full summer foliage.

Page 122: The library catalogue of the University of Wisconsin, Madison, lists fifteen books illustrated by André Dignimont. His artistic style is not unlike that of Whitney Darrow, and his content focuses on a sexual titillation so mild that soft pornography seems much too strong a term. His etchings for Pierre MacOrlan's *Nuits aux bouges, eaux-fortes de Dignimont* (Paris: E. Flammarion, 1929) may be an exception; they had been stolen from the copy seen by me. MacOrlan was also the author of the introductory essay in *Atget, photographe de Paris* (Paris and New York: Henri Jonquières and E. Weyhe, 1930), the first book published on the photographer's work.

Page 126: Maria Hambourg's dating chart, with a list of exceptions, is reproduced in Szarkowski and Hambourg, *The Work of Atget,* vol. 3, pp. 181–85. Molly Nesbit identifies the Atget scholar Jean Leroy as having first identified (in an unpublished paper) the picture in the Le Corbusier article as being by Atget.

Page 128: The data concerning the use of draft animals in Paris during the twentieth century comes primarily from Françoise Reynaud, *Les Voitures d'Atget au Musée Carnavalet* (Paris: Carré, Paris Musées, 1991), p. 113.

Page 136: Henry Miller, "The Eye of Paris" [on Brassaï], in his, *Max and the White Phagocytes* (Paris: Obelisk Press, 1938).

Page 146: While doing background photographs for the film *A River Runs Through It,* Joel Snyder realized that he could emulate the quality of flare found in early twentieth-century photographs by washing the film before exposing it, and thus washing away the anti-halation backing.

Page 170: Le Corbusier's American lectures were published in English, with some revision, as *When the Cathedrals Were White: A Journey to the Country of Timid People* (New York: Reynal and Hitchcock, 1947).

Page 178: The most conspicuous exceptions to the early-riser rule are Arbus, Brandt, Brassaï, and Weegee—a great list, but quite a short one.

Page 182: Joseph Addison, quoted in Christopher Thacker, *The History of Gardens* (Berkeley: University of California Press, 1979), p. 157.

Page 200: Man Ray's letter to White is quoted at considerable length in Minor White, "Eugène Atget (1856–1927)," *Image* (Rochester, N.Y.), April 4, 1956. In April 1974, Paul Hill and Thomas Cooper interviewed Man Ray about his own and Atget's work, when Man Ray was eighty-four; see their *Dialogue with Photography* (New York: Farrar, Straus, Giroux, 1979). Jean Leroy, "Who Was Eugène Atget?" *Camera* (Lucerne), vol. 41 (December 1962), pp. 6–40, seems also to have been based on conversations with Man Ray, and tells similar but by no means identical versions of the familiar stories.

Page 206: Richard Cobb, "La Vie en marge: Living on the Fringe of Revolution," from his *Reactions to the French Revolution,* repr. in idem, *The French and Their Revolution,* pp. 450–55.

Page 210: A monograph by Hubert Juin on Séeberger Frères, *La France 1900 vue par les frères Séeberger,* was published by Pierre Belfond, Paris, in 1979. A generous representation of Sander's work is reproduced in *Citizens of the Twentieth Century: Portrait Photographs 1892–1952* (Cambridge, Mass.: MIT Press, 1986).

Page 212: See note for page 200.

The prints in the plate section were made by Atget, unless otherwise noted, and most are part of the Abbott-Levy Collection in the Department of Photography of The Museum of Modern Art, New York, acquired in 1968 as the partial gift of Shirley C. Burden. They are printing-out-paper contact prints made from 18 x 24 cm (smaller than 8 x 10 in.) glass-plate negatives. The prints are generally smaller than the negatives and vary slightly.

In the plate captions, the titles given in italics are those that Atget wrote on the backs of his prints or on the albums in which he kept them. These notations sometimes include the

year, month, or time of day. Titles or dates not originally noted by Atget appear in roman type. Dates in parentheses are attributed by Atget scholars; dates without parentheses have been documented.

The list below gives three different identification numbers for the plates. The first is the plate number assigned for this volume. The second is the negative number assigned by Atget for his archive, preceded by initials representing the series to which Atget assigned the image. The initials were not given by Atget, but are the work of Maria Hambourg, who sorted the various groups

into an intelligible system. For a full explanation of that system, see John Szarkowski and Maria Morris Hambourg, *The Work of Atget*, 4 vols. (New York: The Museum of Modern Art, 1981–85), esp. vol. 3. The third is the Museum's acquisition number; those with the prefix 1.69 are by Atget; those ending in .80, .81, etc., are prints made subsequently from negatives in the Abbott-Levy Collection. Pictures not made by Atget were made by Berenice Abbott [BA], Richard Benson [RB], or Chicago Albumen Works (Joel Snyder and Doug Munson) [CAW], in the year indicated.

1. LD: 91. MoMA 1.69.3458
2. LD: 602. MoMA 1.69.1245
3. LD: 134. MoMA 1.69.1945
4. LD: 1153. MoMA 1.69.735
5. PP: 26. MoMA 478.80. CAW, 1978
6. LD: 33. MoMA 1.69.1943
7. LD: 1174. MoMA 1.69.723
8. LD: 31. MoMA 1.69.721
9. LD: 861. MoMA 492.80. RB, 1980
10. AP: 3900. MoMA 1.69.1536
11. AP: 4144. v 1.69.4737
12. PP: 360, formerly PP: 3124. MoMA SC 84.46. CAW, 1984
13. AP: 4121. MoMA 1.69.1826
14. E: 6039. MoMA 1.69.1951
15. AP: 4194. MoMA 1.69.2292
16. PP: 363, formerly PP: 3276. MoMA 1.69.889
17. PP: 3196. MoMA 1.69.892
18. PP: 3209. MoMA 1.69.1003
19. AP: 5280. MoMA 1.69.1305
20. AP: 5587. MoMA 1.69.1975
21. AP: 5110. MoMA 1.69.1539
22. AP: 4916. MoMA 1.69.3267
23. AP: 5711. MoMA 1.69.4344
24. AP: 5787. MoMA 1.69.2073
25. AP: 4450. MoMA 1.69.2426
26. AP: 5522. MoMA 168.82. RB, n.d.
27. AP: 6014. MoMA 1.69.1947
28. AP: 6376. MoMA 1.69.1530
29. AP: 6052. MoMA 1.69.1518
30. i: 765. MoMA 479.80. CAW, 1978
31. i: 690. Atget archive. RB
32. i: 741. MoMA 1.69.3177
33. T: 1673. MoMA 1.69.2249

34. AP: 4654. MoMA 1.69.3004
35. AP: 6674. MoMA 1.69.1899
36. AP: 6555. MoMA 1.69.1501
37. LD: 678. v 485.80. CAW, 1978
38. LD: 714. MoMA 1.69.524
39. LD: 697. MoMA 1.69.823
40. LD: 698. MoMA 1.69.824
41. SC: 1226. MoMA 1.69.372
42. LD: 1030. MoMA 1.69.244
43. E: 6033. MoMA 1.69.1255
44. E: 7156. MoMA 1.69.1289
45. E: 6125. MoMA 1.69.989
46. E: 6074. MoMA 1.69.207
47. E: 6652. MoMA 1.69.221
48. E: 6622. MoMA 1.69.1950
49. V: 1225. MoMA 1.69.1955
50. E: 6580. MoMA 1.69.89
51. AP: 6218. MoMA SC 84.60. CAW, 1984
52. PP: 47. MoMA 1.69.998
53. T: 1391. MoMA 1.69.2204
54. ve: 11. MoMA 1.69.2627
55. AP: 6379. MoMA 1.69.1963
56. PP: 351. MoMA 1.69.925
57. PP: 342, formerly Z: 109. MoMA 1.69.937
58. AP: 4642. MoMA 1.69.1952
59. PP: 59. MoMA 43.82. CAW, 1981
60. E: 6808. MoMA 1.69.1071
61. E: 6963. MoMA 1.69.209
62. E: 6961. MoMA 1.69.1785
63. E: 7105. MoMA 494.80. RB, 1980
64. LD: 1046. MoMA 1.69.1198
65. E: 6986. MoMA 1.69.4074
66. E: 7002. MoMA 1.69.48
67. E: 7075. MoMA 1.69.1961

68. E: 7051. MoMA 1.69.1458
69. E: 6813. MoMA 1.69.1559
70. LD: 918. MoMA 495.80. CAW, 1980
71. E: 6990. MoMA 1.69.2732
72. LD: 1045. MoMA 1.69.1101
73. LD: 1054. MoMA 1.69.781
74. AP: 6426. MoMA 1.69.1538
75. AP: 6486. MoMA 214.81. CAW, 1981
76. AP: 6534. MoMA 488.80. CAW, 1978
77. AP: 6660. MoMA 1.69.1711
78. PP: 45. MoMA 1.69.3551
79. AP: 6560. MoMA 1.69.80
80. E: 6504. MoMA 1.69.2994
81. LD: 1082. MoMA 1.69.137
82. SC: 1160. MoMA 1.69.253
83. LD: 1065. MoMA 1.69.3033
84. SC: 1240. MoMA 1.69.355
85. SC: 1261. MoMA 1.69.417
86. SC: 1264. MoMA 1.69.402
87. SC: 1274. MoMA 1.69.405
88. PP: 157. MoMA 1.69.1545
89. PP: 85. MoMA 357.61
90. PP: 83. MoMA 1.69.1544
91. PP: 93. MoMA 1.69.1948
92. PP: 153. MoMA 211.81. BA, n.d.
93. PP: 43. MoMA 1.69.437
94. PP: 96. MoMA 1.69.430
95. PP: 67. MoMA 1.69.441
96. PP: 68. MoMA 1.69.1641
97. S: 18. MoMA 1.69.2694
98. S: 28. MoMA 1.69.1519
99. S: 64. MoMA 487.80. CAW, 1978
100. S: 17. MoMA 1.69.1510